PAINTING
a complete guide

PAINTING
a complete guide

Kenneth Jameson

A Studio Book
The Viking Press
New York

Published in 1975 by the Viking Press, Inc.
625 Madison Avenue, New York, N.Y. 10022

SBN 670–53573–7
Library of Congress catalog card number: 74–21746

This book was designed and produced by George Rainbird Limited
Marble Arch House, 44 Edgware Road, London W2

House Editor: Erica Hunningher
Assistant House Editor: Felicity Luard
Designer: Pauline Harrison
Index by: Myra Clark

Printed and bound in Great Britain

Frontispiece and title page: detail from *White Flowers* by Kenneth Jameson

Contents

Introduction

Painting is a continuing activity with its roots in prehistoric times and its growth extending into the future. In *European Painting and Sculpture* the late Eric Newton dates the birth of painting at about two hundred centuries BC. Cavemen with fluttering wick lamps and coloured earths mixed with animal fats reached up to adorn the walls and ceilings of their caves. Today we use acrylics, sophisticated compressors and spray guns to cover walls. The differences between these two processes in time, media, and techniques are extreme. But at the same time there are many similarities. For instance, the caveman's ochres were probably chemically the same as those we use today, though the way in which they were made was widely different.

Consider for a moment some world-renowned painters: Giotto in Renaissance Italy spreading plaster square yard by square yard on the walls of the Arena Chapel; the wizened, red-headed, eccentric Dutchman Van Gogh, squeezing his oil paints from their tubes directly on to his canvas in the blazing sun of the south of France; the Englishman John Sell Cotman, dodging the Yorkshire showers, sitting on a rock in the middle of the river at Greta Bridge; the anonymous Egyptian 'undertaker' pouring hot melted wax colours to produce a portrait of the occupant of the mummy case; the French court painter La Tour delicately smoothing, with the tip of his ringed finger, the granular surface of his pastel portrait of La Pompadour; the fourteenth-century Sienese painter breaking eggs into a basin to mix his tempera pigments; gentle Vuillard painting quiet French interiors in muted colour harmonies at the turn of the century. These few cover the total time span and the whole range of painting media – acrylics and polymers, fresco, oil, watercolour, encaustic, pastel, tempera, gouache. These and variations of them such as poster and powder colours, emulsion paints, coloured inks, dyes, wax crayons, oil pastels, and chalks are the subject matter of this book. All of them, in fact, can be used for drawing, but we are going to consider them as painting media.

Considering the whole range of painting today it is obvious there are not so many opportunities as there were in the Renaissance to spend a lifetime adorning vast walls in cathedrals and churches with fresco paintings. Frescos in the home are a rarity. Encaustic painting requires workshop conditions with heating equipment, extractor fans and fire

precautions. More artists practise tempera than fresco, Maxwell Armfield and Ben Shahn for instance, though many painters consider the process too finicky and slow, and feel it produces a less positive effect than they desire. Also, eggs are not as cheap as they used to be! Pastel, a beautiful medium, is positively disliked by many. School-children especially tend to reject pastel as smudgy and dusty. Even in the hands of the adult specialist there is the disadvantage of fragility and the riskiness of 'fixing' procedures. So it will be seen that social and practical reasons tend to reduce the most frequently used painting media today to four: watercolour, oil, gouache, and the comparative newcomers the acrylics and polymers.

These considerations have determined the structure of this book. The first chapters deal fully with the four most popular media; these are followed by introductory chapters on the less frequently practised media for the reader who may wish to experiment with them. The chapter entitled 'The painter's vision' is concerned with general matters relating to all media. Does the artist conceive an idea and then select a medium and equipment to execute it, or does he begin by trying out colours and brushes and techniques and then, as he proceeds, do ideas occur as a result of what he is doing, with say, paint and canvas? The answer is that both can, and do, happen. Which way round they happen depends upon the personality, sensitivity and mental attitude of the painter. Jackson Pollock worked by the second method; John Constable used the former.

We are all students. Even the great Turner remained a student all his life. It is vital for every student to find the method and the medium which suits him best, and the only sure method of doing this is by trial and error. This book is written for all painters whether professional, amateur, or student, and the readers' motivations to paint will be as various as the different individuals concerned.

There is no real dividing line between amateur and professional, or, if there is a difference, then it is in attitude more than anything else. The so-called amateur who sets himself the task of accomplishing two hours painting per day, come what may, and in so doing denies himself the usual social indulgences, and who rigidly adheres to this routine, is more professional than the professional who has exceptional ability and training but who is not able or willing to apply himself, and so fails to keep to a regular work schedule.

The book will assume: first, that the reader is 'dedicated'; second, that he is in the first stages of becoming a painter; and third, that he is in search of basic advice.

Let us begin with watercolour.

1 The watercolour medium

'What, and when, were your first practical experiences in painting?' If every reader were asked this question it is likely most would give some such answer as, 'I was given a box of paints for Christmas when I was five years old.' Do you remember those black japanned boxes of watercolours? They still exist, not always black, and in three varieties. Those on sale in toyshops, containing an array of granite-like chips, masquerading as pans of pigment which yield little or no colour when used, and wear out the young painter's patience, and his brush. This toyshop variety does not come within the scope of this book, except as a warning. The child who experiences only this kind may well be put off painting for life. Toy paints should not be given to children if the aim is to encourage their powers of expression. They are artistically quite useless.

The second type of watercolour box is the type known as 'student's' quality. These are relatively inexpensive and are suitable for students' rough work. They are also ideal for children's use.

The third kind are 'artist's' quality watercolours. The difference between 'student's' and 'artist's' varieties is in the method of preparation, the quality of the raw materials used and the fineness of their grinding. The student who takes up watercolour as a serious study should use the best quality 'artist's' paints.

In the past small watercolour boxes were the only provision for painting in schools. The result is many adults think first of watercolour when painting is mentioned. And these two facts combine to produce a climate of misunderstanding about watercolour painting. It is deemed to be simple enough for a child to practise. Therefore it is thought to be an *easy* medium. Nothing could be further from the truth.

Let us try to establish what watercolour is. Just because a paint is mixed with water, and applied with water, does not mean it is watercolour. Gouache, poster colours, powder colours, tempera, acrylic pigments are all used with water, but none are watercolour in the sense we are going to look at it.

The pure transparent watercolour is to painting what the string quartet is to music. In the string quartet the musical components are few and exposed. The slightest flaw in performance is immediately apparent. Only perfection is tolerable. The pure watercolour, that is to say the watercolour achieved with a maximum of three superimposed

transparent washes, has an unique simplicity and calls for the same perfection of technique as fine string-quartet playing. If there are flaws they are just as apparent. At its best watercolour can provide jewel-like works of art of the highest genius. The English language has no word which exactly means what I understand by the term watercolour. The French use the word *aquarelle* to mean the classic transparent watercolour as exemplified in the work of Philip Wilson Steer, J. M. W. Turner, John Singer Sargent, David Jones, John Sell Cotman, Thomas Girtin, Winslow Homer, Edward Hopper and Andrew Wyeth.

As a medium watercolour is immediate, spontaneous and direct. To set out to achieve perfection is an arduous undertaking, yet, to a degree it is within the grasp of the truly dedicated student who has the will to practise hard and continuously.

Equipment and materials

I believe that every student should begin with the minimum of materials and equipment and, gradually, as the need arises, and only when that need becomes imperative, extras should be added.

The basic materials for watercolour are: brush, paper, four or five half pans, full pans or tubes of colour, water and water jar, mixing palette (or plate), board to support the paper, drawing-pins (thumbtacks), pencil, a method of fixing the paper to the board, and a sizeable piece of clean white absorbent rag.

BRUSHES It is possible to paint a good watercolour on poor paper. An experienced painter can produce a good painting with second quality paints. It is virtually impossible to do anything with a bad brush, even if the painter is highly experienced. If you have made up your mind to explore watercolour as a practising painter and intend to make a special study of its practical aspects, I advise you to treat the brush as of first importance and to buy the best. At first it is possible to do everything you wish with one good quality, size 7, sable hair. The best are expensive because the hairs are pure mink. The best mink hair for brushes comes from the tail of the male Kolinsky, or Siberian mink, found only in Russia. No other hair has so many desirable qualities, such curve, such spring both when dry and wet. Kolinsky hairs produce a brush with a fine point and a good bulk of hair to hold ample liquid paint. But springiness is the vital quality. The more accommodating stores will allow you to test the springiness. The standard test is twofold. Dip the brush into clear water and shake out. The brush should return to the shape shown in the illustration. Dip the brush again and make a stroke on a piece of clean paper. Shake out again and once more the brush should return to shape.

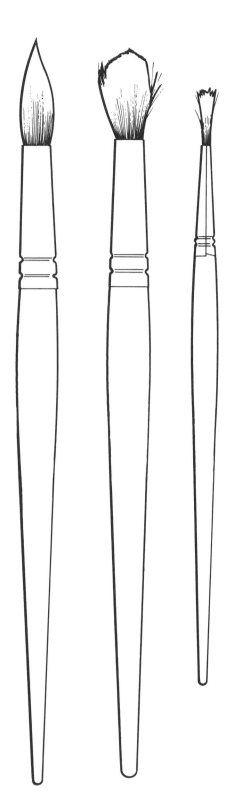

10

(*left*) A good brush keeps its shape. The splayed ends indicate sub-standard hair; such brushes will never function satisfactorily.

(*below*) The homemade brush holder. Use an elastic band to keep the side lid in place.

Watercolour has a lot in common with oriental brush calligraphy. You should be able, easily, to write with a good watercolour brush, as you would with a pen or pencil. In order to understand in a practical way differences in springiness, try a simple experiment. Dip a piece of soft string into ink or paint and try to write your name. Now sharpen to a point a sliver of wood, a straight dead twig ¼ in. (6 mm) thick will do. Dip it into ink or colour and write with that. The string will be virtually unmanageable. The stick will write easily but will be inflexible. The sort of brush you need will be flexible and at the same time resilient. It will hold a generous load of paint but will still be manageable. Reject any brush which splays, flops, curls up, or spreads at the tip.

A good quality brush will last for years. Take care of it. Store it when not in use, with its point guarded, and its hairs protected by a small sachet of moth repellent chemical. A homemade brush holder is illustrated. The brush handles are drilled and threaded on to the wire, which holds the points clear of the side of the case. This device provides completely safe storage. Another efficient carrier can be made by cutting a lath of wood to 2 in. (5 cm) longer than your longest brush, and fastening your brush(es) to the strip with a strong rubber band, making sure that the strip protrudes beyond the brush tips. Cut a length of cardboard tubing long enough and wide enough to accommodate wood strip and brushes and also leave room to insert a bung in the other end. Make a wooden bung for the other end. This will work efficiently so long as you keep an eye on the rubber band which will tend to perish. Renew it often. Whatever arrangements you make, the object, always, is to protect the brush tips. They are very delicate.

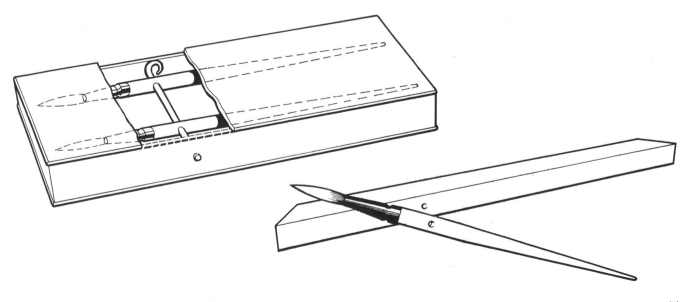

PAPER Commercial exigencies have divided the paper making industry into two sectors, the giants of mass production, and the few, dedicated, smaller firms who still take pride in producing high quality papers for the artist. Many familiar brands have disappeared from the scene and new names appear. In Britain and the United States it is still worth searching for the old favourites, David Cox, Whatman. Some stocks remain, but mainly one has to be satisfied with new brands.

Ralph Mayer in his authoritative *The Artist's Handbook of Materials and Techniques* (see Further Reading page 148) gives first place to European papers. A number of these, Bainbridge, Strathmore, d'Arches (from France), Fabriano (from Italy), are available in the main cities of the United States and Britain.

The best known makes in Britain today are R. W. S., Bockingford, Hollingsworth, Reeves Watercolour Paper, Rowney Georgian Watercolour Paper, and Saunders. Look around and see what you can find. There is still a good choice in spite of the disappearance of many old varieties. You will need to spend time trying various types before you find a brand which suits *you*. It took me quite a while to discover that I did not work well on coarse grained paper.

Paper is sold by weight per ream. In the metric system a quire is 25 sheets and a ream is 500 sheets. A ream of watercolour paper which weighs 72 lb (155 gsm) obviously comprises 500 sheets of thinner paper than a ream weighing 140 lb (310 gsm). Paper varies in thickness. It also varies in surface texture. The grades are: Hot pressed (smooth); not hot pressed, generally shortened to Not (medium), and Rough. Some papers are more absorbent than others. Once again you must try samples of each and make your choice. Good quality cartridge, or drawing paper, can be used for watercolour work but it tends to be more absorbent than watercolour paper as such. Coloured papers in a variety of off-white tones, warm and cool, were at one time much in vogue. They are not so readily available today.

The advantage of a tinted paper is that it makes it easier to achieve harmonious colour. If the painter is working on a composition of warm tones a warm-tinted paper will help. A snow covered landscape will be aided by a cool-tinted paper. If they are unable to obtain tinted paper some watercolour artists will get round this by laying a wash of appropriate colour all over the paper before they start the painting. David Cox was at one time a well known tinted watercolour paper produced in shades of off-white ranging from very warm, through neutral, to cool dim grey. It is still possible, occasionally, to run supplies to earth by the simple device of asking at every art store you find.

Supposing that you have decided upon the paper you prefer, you then need to make up your mind about how you will use it. You have

the choice of pinning single sheets to a board; using watercolour books which you can make yourself or buy from the art stores; or you can stretch the paper. I will deal with 'stretching' under working procedures.

PIGMENTS Artist's suppliers list varying numbers of watercolour pigments in their catalogues. The larger manufacturers include in their catalogues a chart showing the composition, properties, and permanence of their colours. These are a helpful guide. When deciding upon colours you are going to use, choose those that are permanent and, if possible, transparent. You can test their transparency by drawing a ravel of pencil lines on a sheet of white paper and then floating washes of the various colours over. The lines should remain visible through the colour. In fact virtually all watercolour pigments are transparent if they are laid dilute enough, so try heavy washes as well as thin ones.

To begin with buy three colours only, unless some benefactor offers you some paints as a present. Then get a larger number, but in the first stages, *use* only three colours. Try burnt sienna, raw sienna and Prussian blue. Both burnt sienna and raw sienna are natural earth colours containing iron oxide and they are permanent and transparent. Prussian blue is a powerful transparent pigment made from potassium ferric-ferrocyanide. It is reasonably permanent in watercolour and works well with both raw and burnt sienna. When you buy watercolour paints you will have the choice of full pans, half pans, and tubes of colour. There are advantages in all three. Colours are expensive so buy half pans of colours you use rarely and full pans of those you use often. Once you remove the cellophane covers from colours in pans drying begins. Sometimes this drying adversely affects the colour and causes delay in use. Paint in tubes does not dry out and is economical in use because you squeeze out only as much as you want at one sitting. Complete sets of paints are sold in boxes which serve as containers and also as palettes. They are neat and convenient in use. Watercolour palettes are either integral with the paint box or they can be bought separately.

WATER AND WATER JARS It is a good idea to keep an eye open in the kitchen for a couple of screw-top jars. Wash them thoroughly, especially if they have previously contained greasy substances. Take out the linings of the lids and replace them with clean, non-greasy linings of card or other suitable material. Avoid the slightest trace of grease. It would be disastrous.

When painting keep two pots of water in use. A 'dirty' jar to rinse brushes in, and a 'clean' jar to mix paint with. Remember that tap

water is drinkable but it is not necessarily free from chemical and organic matter which may react with the paints. It varies from district to district. Test it by trial paintings. Watch out for granulation, especially of blues. If in doubt buy distilled water.

BOARD Find a piece of either Essex board, soft chipboard, or soft whitewood of convenient size, say 12 × 14 in. (30 × 35 cm). Make sure it is soft enough to take drawing pins (thumbtacks), and that it is not too thick ($\frac{3}{4}$ in. or 19 mm is about right). You can if you choose buy a drawing board from the art store, but this is not essential in the very early stages.

MISCELLANEOUS EQUIPMENT Small sponges are useful for cleaning up, wiping out, and occasionally for painting with. If you use one for painting do not let it become a habit in the early stages. Too much use of it will make your work look 'tricksy'. There is no satisfactory substitute for the brush.

Always carry a small sheet of clean white blotting paper. Attach it to the painting board or tuck it between the pages of the sketchbook in which you propose to work. Leave its edge protruding. It is useful for two things. A too heavily loaded brush can be touched on to its surface and this will draw out some of the water or paint, or all of it if the contact is prolonged. This is a better way than 'pinching out' the bristles. Pinching is a drastic process which could damage the brush. As described under 'Wiping-out techniques' (see page 20), an appropriately shaped piece of dry blotting paper will remove an area of colour from the middle of a larger wash, if that is desired, resulting in a two-toned wash, achieved with precision. Paper tissues, it is worth repeating, can be invaluable. They are excellent for mopping up, cleaning the palette from time to time during work, and at the end of the session.

Finally add a dozen good quality drawing pins (thumbtacks) and a clean white absorbent rag.

You are now equipped to start preliminary practical studies.

Studies

I use the word study in the sense of a Chopin étude, a piece of music written as a work calculated to develop, one at a time, different aspects of the pianist's technique – left hand, finger muscles, the ability to negotiate arpeggios. The studies which are now suggested are each designed to develop different aspects of the watercolour artist's technique. It is vital that you should begin by acquiring certain basic skills. The only way to do this is to undertake a stint of repetitive

practice. Watercolour is a precise art calling for firm self discipline.

Take a middle course at first. Begin by choosing a white paper of medium roughness, i.e. Not, of fairly substantial weight, say R.W.S. 140 lb (310 gsm). This is a fairly thick paper and so can be used without elaborate stretching procedures. It can be merely pinned to the board. The thicker paper is less likely to buckle (or cockle) when wet.

STUDY ONE: LAYING AN ALL-OVER WASH Pour water into a small shallow dish, or palette with room for a large wash. Using the brush mix in, say, Prussian blue until you have a good puddle of strong colour. Tilt your board at an angle of about 20 degrees by propping it on a small block of wood. Charge your brush with colour and, starting from the top left if you are right-handed and from top right if you are left-handed, lay a wash. Move the brush firmly and at an even speed along the top edge of the paper so as to produce a fairly wide band of colour.

Laying an all-over wash. Work at a steady speed and use rather too much than too little liquid. Fluidity is essential. If you vary the pigment density you will vary the wash, so be lavish. Mix too much colour before you start.

You will note that the liquid runs down to the lower edge and collects there. Recharge the brush and repeat the process 1 in. (2.5 cm) lower down and joining with the line above. Continue to repeat the process until the paper is completely covered. Touch the brush dry on the rag and drag the dry bristles along the accumulation of colour at the bottom edge of the page. The dry bristles will pick up the excess colour. Dry the brush again and complete the mopping up. Leave the wash to dry. When it is dry examine it critically and see whether it is even and if there is an equal density of colour all over.

Repeat the process with a piece of cartridge (drawing) paper. Notice the difference in absorbency. It will be more difficult to lay an even wash on cartridge because of its absorbency. It is also likely that the unevenness will take the form of patches, varying in depth of colour and visible brush strokes.

Repeat the process again on a piece of hot-pressed paper. Judge whether you prefer its smoothness to the texture of the other papers. Try a piece of rough-surfaced paper. A number of art suppliers and paper makers supply sample booklets of papers of various surfaces and thicknesses, which provide a means of trying out various types of paper and making choices.

STUDIES TWO AND THREE: GRADUATED AND MULTICOLOURED WASHES These are two variations of study one.

Study two is a method of producing a wash of one colour which graduates from light at the top of the paper to dark at the bottom, or from dark at the top of the paper to light at the bottom. This is accomplished by either adding a touch more paint to the puddle between each stroke when laying the wash, or, in the other case, by adding a little clear water to the puddle and so lightening the colour progressively. When painting landscapes these wash techniques are frequently needed.

The second variation is the mixing of multicoloured washes. This is achieved by mixing three different puddles, as we are using only three colours. Lay the wash exactly as in study one but interchange the colours as you proceed. Wash the brush between each application of paint. Make the rows of colour even and continuous, and make the joins between one colour and the next, if they occur in the same row, fuse together.

STUDY FOUR: SUPERIMPOSED WASHES With transparent pigments you will find that beautiful and subtle effects can be produced by laying one wash over another. Allow the first wash to dry completely. Then float a second wash over the first. Let the first wash be light and strong in

colour. Of the three pigments we are considering at the moment, raw sienna, burnt sienna, and Prussian blue, a strong wash of raw sienna would best illustrate the point. Lay it and let it dry. Then superimpose small washes of all three colours over the first wash. Observe the effect. Raw sienna on raw sienna provides a two-tone area of the same colour. Prussian blue in various intensities, laid over raw sienna provides a range of subtle greens. Note, for the best effects, the second, or superimposed, wash should be darker and weaker than the first. Next lay an initial wash of Prussian blue and repeat the process of laying small washes of each of the other colours on that. Then thirdly lay an initial wash of burnt sienna and superimpose again. You will soon find that some combinations of wash will be more satisfactory than others. You will also find that watercolour dries slightly lighter in tone than when it is wet. A useful rule of thumb is that light, strong coloured washes overlaid by darker, less intense colours, produce the most luminous and purist results.

Master the skill of being able to control and foresee the final effect of one wash upon another, and you will be well on the way to mastering watercolour painting.

STUDY FIVE: BROKEN WASHES A broken wash is an area made up from a number of non-continuous smaller washes, loosely painted, overlapping in places, but homogeneous in effect. In other words it remains one wash even though it is made up from many small washes.

(*left*) A superimposed wash. The first wash must be completely dry before you lay a second wash.

(*right*) A broken wash. It is virtually impossible to produce a watercolour painting without using this technique.

STUDY SIX: INTERRUPTED WASHES These consist of all-over washes in which gaps have been left. An example is a sky wash in which gaps are left for clouds. The shapes on the paper which are to be left unpainted should be plotted with a grade H pencil, finely pointed. Soft black lead tends to sully delicate transparent washes. Having indicated the gaps proceed as in study one, lifting the strokes of paint where the gaps are indicated. This type of work tends to encourage the formation of small puddles of colour. Touch these off with a dry brush as soon as possible.

STUDY SEVEN: WET INTO WET Lay an all-over wash on a sheet of paper and experiment by charging the brush, separately, with various colours and then adding wet colour to the wet surface. Note the different effects as the initial wash gradually dries, and when you add wet colour at different stages of the drying. When it is very wet the second wash will run and spread and mix. When it is half dry the running will be very much less. It is necessary to explore this process. You may wish to incorporate soft edged washes in some kinds of work. Repeat this study until you can control the process with confidence.

STUDY EIGHT: LINEAR WORK All the above suggestions for work relate to areas or shapes of colour. Grasp of the skill of applying these is essential, but it is only part of the technique of watercolour painting. It is also necessary to gain control over the brush as a linear tool. It is necessary to practise making considered, calligraphic linear images, lines, crosshatchings, and other configurations. *Barges at Whitstable*, by Philip Wilson Steer, illustrated on page 25, consists of an all-over wash with a broken wash superimposed on its upper section, and with a multicoloured wash from the horizon to the bottom of the page. The drawing of the barges is a kind of calligraphy. It looks deceptively simple. In fact the opposite is the case. It takes long and arduous practice to achieve the tension, the freedom coupled with precision, which one can see in this exquisite work. Steer's handling of this subject implies complete control over the tip of the brush used as a drawing implement. So, begin study eight by making a page of carefully controlled linear brush strokes. Be bold. Take risks in this exercise.

When you feel competent to produce good tense linear passages at will, and with certainty, and to link this with the experience you have gained as a result of carrying out the exercises already described, then you possess the basic skills to move forward to the next step which is picture making. But before we do this, we must look at one or two other techniques which every watercolour painter should have up his sleeve. Though, if he is a purist, he will only use them as a last resort,

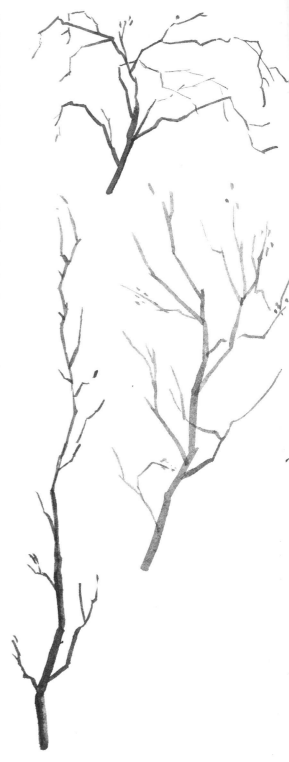

Linear brush strokes.
(*left*) Transcriptions of growth rhythms of
trees showing the quality of tension. These
brush strokes have much the same quality
as brush calligraphy. (*right*) Practise mak-
ing various linear images, for example, a
stipple, a simple crosshatch, strokes made
with a fluid loaded brush, with an almost
dry brush, with the end of the brush
handle; make a flat wash and scratch
through it with a metal point.

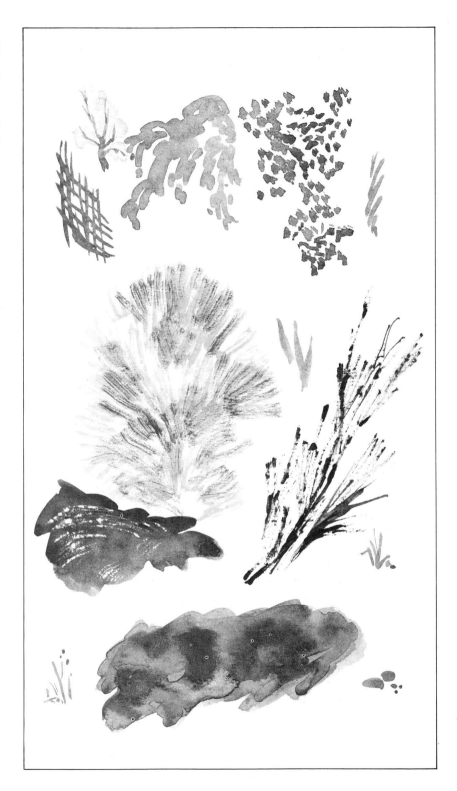

or for special effects which cannot be achieved by the traditional *premier coup* method. Beware of tricks which may take 'life' out of your work. Spontaneity is the key word in good watercolour, the sort of spontaneity which is so well exemplified in John Constable's landscape sketches in both watercolour and oil, which are preferred by many of his admirers to his large scale and highly finished works.

At the end of this study section, I suggest that what we have been discussing is a set of 'five finger' exercises which are essential for the watercolour painter who wishes to master the traditional pure water-colour technique. They should be practised until they become second nature. They should not preclude the student from attempting 'subjects' as such, but they should form an essential part of a daily routine of study.

It will be noted that we have referred only to first and second washes. Never use more than three washes, and never use three washes if two will do.

Wiping-out techniques

Most watercolour papers have a tough, hard, not very absorbent surface. It is possible to remove unwanted paint by rubbing with a clean wet rag. To make small adjustments to the painting, make a fine point by wrapping a piece of clean white cloth round the end of a thin brush handle or pointed stick. Dip in water and rub the paper surface. This method is effective on wet or dry paint surfaces.

Another method is to use a paper mask or stencil, cut to the required shape and laid over the painting where the paint is to be removed. Rub over it with a pad of soft cloth or a small damp sponge. Take care not to break the surface of the paper. It is tough but it is not impregnable. This method is also effective on either wet or dry work.

A third method is to work over the paint surface with a watercolour brush and clean water. Scrub it gently. Keep a small piece of new blotting paper, absorbent cloth or paper tissue handy, and when the paint film is loosened press the absorbent material firmly to the surface. Some of the colour will be lifted.

Sometimes too much, or too strong, colour is accidentally applied at the beginning of work. If this happens the quick application of a piece of new blotting paper to the wet paint surface will remove some of the colour. It cannot be stressed too strongly, however, that the aim of the watercolour painter should be to achieve all the effects he desires without the use of expedients. The brush, colour, and paper, in themselves, in the trained hand and in response to the sensitive eye, should be enough.

Choosing subjects

We must make more assumptions at this point:

1 That you find the watercolour medium attractive enough to make you want to explore it.

2 That you have practised all the studies and feel able to carry out any of them successfully, as and when you want to.

3 That you have decided on a type of paper which suits your aims.

4 That you now wish to combine all these in pictorial form.

It is important at this stage to attempt to make a subtle point. It has to do with suitability of subject matter to the watercolour medium. Perhaps appropriateness, or compatability, might be better words. The essence of the matter is that not all subjects lend themselves to transposition into watercolour. Some are totally unsuitable. Take a parallel case in music. Mendelssohn wrote his violin concerto for a suitable instrument. Imagine the double bass attempting the opening bars of the first movement! The double bass is not an appropriate instrument. It is heavy and slow to manipulate in comparison with the violin. Another example of incompatability, in the field of ceramics, would be the making of clay models with long slender projections. Even if the projections survived the firing process they would always be at risk of being broken off because of their brittle nature. On the other hand it is perfectly possible to make a model of, say, a hedgehog, from metal.

Which would lend itself best to treatment in watercolour wash, a football crowd, or a range of mountains with an undulating foreground and a group of trees in the middle distance?

To look at a subject and say, 'Could I do that in watercolour?' is to begin from the wrong end. Some virtuosi can do it. Some Victorians, Birket Foster for instance, did do it, without detracting from the pure watercolour quality of their work. William Russell Flint is another, later, virtuoso who could do it. They could be said to be the exceptions who prove the rule. I believe the best rule to follow is to think in terms of watercolour wash and brush drawing, and then look around for a subject which will give you a chance to use your skills in laying washes of all kinds and in drawing with the brush. Before long you will be saying to yourself, 'That looks like a watercolour, even before I begin to paint!'

Subject matter should be an excuse, or a reason, for you to assemble together a collection of exquisite watercolour effects. If the subject puts restraints upon the watercolour medium, or poses problems which cannot be solved in watercolour terms, then abandon the subject.

Chelsea Reach by Wilson Steer (page 22) looks simple, yet this kind of watercolour is the result of years of patient practice in analysing, and judging, visual effects in the environment, and then translating these

into watercolour terms. The secret is practice. Steer lived in a house on the Thames Embankment and he painted the river literally hundreds of times. Perhaps the best advice one can give is to say, pick one simple subject which lends itself to watercolour treatment, such as *Chelsea Reach*. Look at it again for a moment before we go on. It consists of two broken washes for the sky, a simple wash delineating a strip of buildings, two parallel horizontal washes for river and river-bank, and a simple superimposed group of wash notations for the barges. Now think in these terms and go and look round your immediate locality, your garden. Select a simple subject which suggests three or four uncomplicated washes. Practise, with your three basic colours,

Chelsea Reach by Philip Wilson Steer (1860–1942). Watercolour, 9 × 11¼ in. (23 × 28.5 cm).

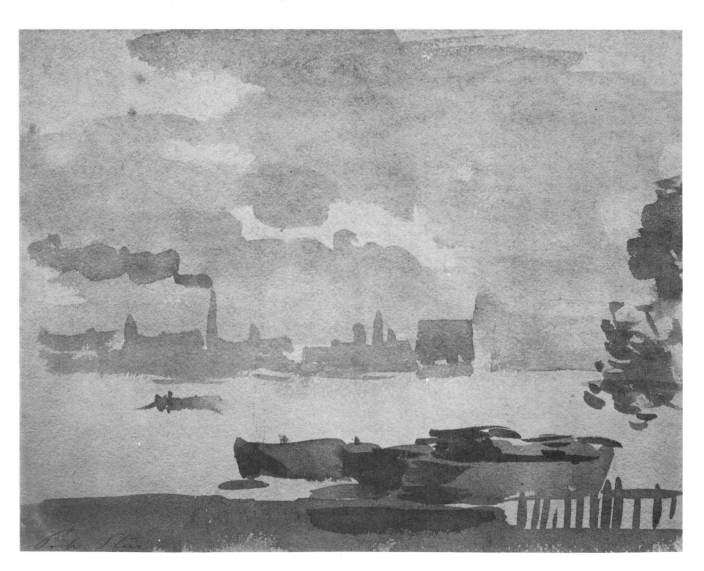

Two studies of the same elderly apple tree from a watercolour sketchbook.

getting as near as possible to the colours in the subject before you. Practise the same subject again and again, as Steer did, until you master the technique of stating it simply and directly in terms of clear transparent washes and brush drawing. A further study/exercise is to keep a watercolour sketch book and make continuous studies of skies, at least one a day: grey skies, evening skies, spring skies, there are never two alike. Cover the whole of each page with sky, and gradually you will begin to see ways of producing certain effects. In other words your style will begin to form. It is a most satisfying form of study. Every new attempt will add new experience of the watercolour medium to your memory bank.

If you are lucky enough to live in the country select one tree and practise rendering it in terms of a shaped wash against a wash ground. Repeat it in different weather conditions, in different lights, and at different times of the year. If you do not live in the country explore the local park for a single tree. Find a tract of open country and look for a hedge, or a dry-stone wall running right across it. Practise brush drawing by laying a background wash and then, when the wash is dry, by drawing an irregular, interrupted, line representing the hedge or wall, and use the line to explain the three dimensional shape of the land.

If you live by a busy river, sort out a simple subject in the style of Wilson Steer and translate it into terms of watercolour. Do not stop after one attempt.

TIMING In choosing subjects you will soon discover, often the hard way, the importance of timing. When applying one wash on top of another there is one precise moment which is the optimum moment to

do so. A couple of seconds too soon and the colour runs, a couple of seconds too late and the top wash produces too hard an outline. Exact judgment in matters of timing can be achieved by constant practice and by closely watching what is happening as you work.

STUDY OF THE MASTERS Every time you look at an original watercolour, or a good reproduction of one, a little bit is added to your knowledge of the medium and you grow as an artist, even if ever so little. Therefore seek out and carefully peruse the work of the great watercolourists. Philip Wilson Steer has already been mentioned more than once, so have J. M. W. Turner, John Sell Cotman and John Constable, and the Americans Winslow Homer, John Singer Sargent, John Marin, Edward Hopper and Andrew Wyeth. Add to these Paul Sandby, Richard Parkes Bonington, John Varley, John Crome, Thomas Gainsborough, Alexander Cozens, Francis Towne, Peter de Wint, Samuel Palmer, Edward Lear, Paul Nash, John Piper, David Jones, Paul Klee, and finally but not least Thomas Girtin, of whom Turner said, 'If Tom Girtin had lived I should have starved.' One more distinguished name should be added to the list, David Milne of Canada, a superb and highly personal artist. All the above names have something to give you as a student. Study them. In some of them you will see the style of working we have been considering, the pure watercolour. In others you will see divergences of technique. Some of the divergences are so wide they amount to totally different styles. But this does not invalidate the approach I suggest. If you develop the skill of pure watercolour, you will then have the choice of staying with that as your style, or you can diverge and establish a new style.

Keep an eye open for books (see page 147) and articles on watercolour, whether they are about painters, or instruction in the art of watercolour. Read everything, see everything. Learn to stretch your mind, to discriminate.

Beginning a painting

'Should I draw it first?'

Let us look at a simple landscape carried out by a beginner (illustrated on page 26), and go through the painting of it step by step. I will comment upon problems as they arise. Perhaps we can anticipate one problem before we start. This is the time for adding more colours to your box; which will you choose?

With the very lightest outline, in grade H pencil, indicate (1) the outlines of the clouds, (2) the skyline and the baseline on which the band of trees stands, (3) the general outline shape of the group of trees on the left, and the lines of the very distant land forms. A cautionary

Barges at Whitstable by Philip Wilson Steer (1860–1942). Watercolour, $8\frac{7}{8} \times 11\frac{11}{16}$ in. (22.5 × 28 cm). This modest painting reveals Steer's mastery over the medium. Its apparent effortlessness is misleading. It is the product of years of practice, a secure technique and an unfaltering eye and hand.

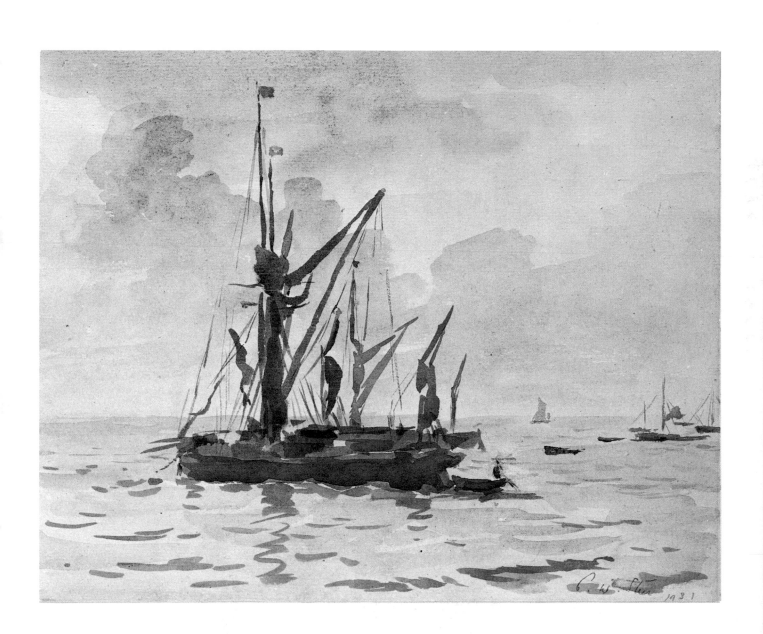

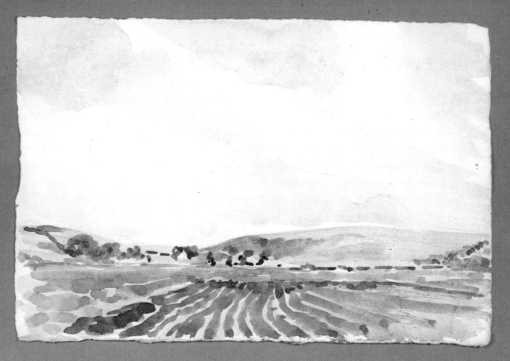

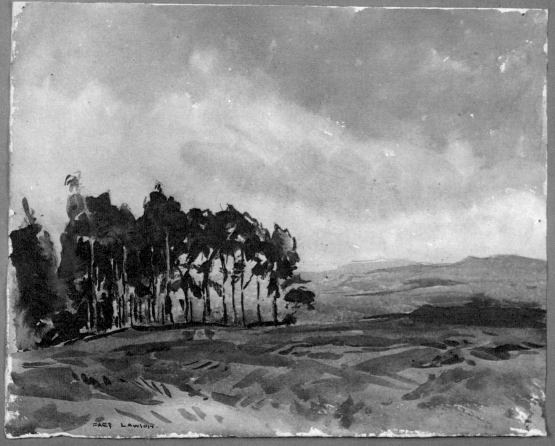

FRED LAWSON.

(*top*) *Rough Ploughed Land*, a simple watercolour study by a beginner. The student worked on a small white 'Not' paper, 10 × 7½ in. (25 × 19 cm).

(*below*) *Above Castle Bolton* by Fred Lawson (1888–1968). Watercolour, 9 × 11½ in. (23 × 29 cm). The special quality of this work is the rich luminosity of the closely related warm tones. It should be looked at in comparison with the student's landscape and with the David Jones (page 127) and the Constable (page 34).

word at this point. Avoid at all costs the seduction of the drawing. If you draw the subject too precisely, and in too much detail, you will end up with a tinted drawing. This is very far from pure watercolour. The niggling filling in with colour of small shapes or outlines is the exact opposite of free spontaneous watercolour. The initial drawing should serve merely as a shorthand note of the position of the main masses, *not* as a representation of the subject.

Although the pencil outline was quickly done, it was carefully considered first so as to produce a pleasing composition, in other words a harmonious assembly of shapes.

The next step in the work was to cast an interrupted wash of warm blue across the sky, leaving the cloud areas white. Prussian blue is a cold blue so you will need to add a warm blue pigment to your collection: permanent blue, ultramarine blue, and cerulean blue are the most suitable. (Permanent blue and cerulean blue are the best as some ultramarines tend to granulate in watercolour wash.)

Then at skyline level, a merging change was made to a wash of warm raw sienna which was continued to the bottom of the page, strengthening the raw sienna the lower it got towards the bottom.

The next step was, as it were, to start at the point in the picture which appears to be at the greatest distance from the viewer, i.e., the very distant Welsh hills, which on this day were cool grey in colour. How did the student mix the pale grey? There are a number of mixtures which produce grey. They consist generally of one of the reds, including the earth reds, mixed with one of the blues. The warmth of the resulting grey depends upon how much red you use in the mixture, and the coolness depends upon how much blue (see page 28).

It was a warm autumn day, the land forms were parched and golden. Raw sienna was floated between the skyline and the ground line. When that wash was dry the distant tree group was put in with a wash mixed from Prussian blue and burnt sienna, with a preponderance of blue. This produced a dull green through which the underwash of warm sienna shone luminously. The plough furrows were next drawn, with the brush, in a mixture of raw umber and alizarin crimson. The crimson was a newly added colour. The study was then finished off by laying a green wash and a delicate version of the furrow colour on the left, and a small, cool green wash on the right. In no place were more than three washes used. The study is not a brilliant success, but for our purposes it is a clear example of the sequence of painting.

MIXING COLOURS The best way of coming to terms with the characteristics of pigments, in any medium, is to experience what happens when you actually mix the colours. It is helpful to fix a piece of scrap

P.P.A.—B

paper, of the same variety as that upon which you propose to work, adjacent to your working surface. It is wise to play safe by testing each mix before you place it on your composition. If you are trying to develop a *premier coup* technique it is necessary to be right first time. A test gives you added certainty that your mix is what you intended it to be.

There are, however, some rules of thumb for mixing colours. If you wish to produce a green in watercolour you can mix it in two ways. You can use, say, Prussian blue and lemon yellow, or Prussian blue and raw sienna, and mix them in the palette. The sienna would produce a less strident green. This is the first method. The other method is to lay a wash of either of the two yellows, allow it to dry and then apply a wash of Prussian blue over the top. In the first method the green is produced by mixing before applying. In the second the colours are *not* mixed first and the green is the result of overpainting. The second method is likely to give a more luminous result, but it requires more experience to achieve the exact colour you require because you must allow for lightening of colour intensity on drying.

There are certain standard mixes which are useful. You can mix gentle greys using (1) raw umber and ultramarine blue, (2) scarlet and Prussian blue, (3) Indian red and ultramarine blue (or permanent blue), (4) cerulean blue and burnt sienna, (5) Indian red and cerulean blue. And there are other combinations which work equally well; experiment by searching through practical mixing. It is better to make a dark, neutral mixture than to use black. Black is very opaque and tends to muddy the more delicate washes. Greens are notoriously difficult to deal with especially in landscape painting. Begin by being restrained.

Starting at page 122 suggestions are made for positive explorations which will sharpen your sensitivity to colour through mixing. Try them in watercolour and see how you react to them.

ADDITIONAL COLOURS The suggestion that you should start with only three colours was made to persuade you to see how far, artistically, you can go with small means. From the experience of following through the painting of the small landscape you will have realized that you cannot get very far. Once you begin to work in front of nature you cannot manage without adding to your range of colours. I would still urge restraint.

I suggest you base your choice upon:
Reds Alizarin crimson, permanent red, Indian red, Venetian red
Yellows Lemon yellow, raw sienna, yellow ochre, cadmium yellow
Blues Cerulean blue, cobalt blue, permanent blue, Prussian blue
Browns Burnt sienna, raw umber, burnt umber
Black Ivory black

The above palette of sixteen colours will give you all that you will ever need. The number could be reduced with no harm done. As you will see there are two earth reds, two bright yellows, and cerulean and cobalt blue. These are alternatives rather than essentials. They are all permanent except, oddly, permanent red, and Prussian blue. What is really meant is that they are permanent under most normal circumstances. Unhappily there are no permanent versions of these colours to date. They are all transparent except for Indian red, Venetian red and ivory black, though cadmium yellow, cerulean blue, permanent blue, and raw umber are betwixt and between in transparency, depending on manufacture and brand name.

You will note that at no time has it been suggested that white should be given a place in your watercolour box. If it were used this would change the medium from watercolour to gouache (see page 64). In pure watercolour, or aquarelle, which we are discussing, the effect of white is achieved by leaving the paper uncovered or, second best, by scraping through the paint film with a sharp knife when the wash is dry.

STRETCHING PAPER On page 15 I suggested that you begin by choosing a paper of medium roughness. Some readers may prefer to work on larger and thinner papers, in which case the paper needs to be stretched by some means. A common practice is to immerse the paper in water; the bath tub is a convenient container. Remove the paper and allow it to drip until all surface water has run off. Then lay it on the drawing board and fix the edges, with an overlap of about $\frac{1}{2}$ in. (1.5 cm) all round, using gummed paper. It then dries completely and, because it shrinks as it dries, it dries taut. This surface is highly satisfying to work on. It allows the painter to use thin paper which, unless stretched in this way, would when wet bubble, bulge, or cockle.

Stretching is a somewhat tedious business and it may inhibit the sort of panache called for in free, transparent, watercolour painting. One might tend to think, 'I must be careful, it takes so long to prepare paper.' But stretching is probably desirable for larger work in the studio. Manufacturers of artist's equipment supply some ingenious stretching frames which make the process much easier. No gumming is needed. A disadvantage is that you are limited by the size of the frame.

Immersing and stretching the paper renders the surface more receptive to washes.

Sometimes new watercolour paper may have a very slightly greasy surface. Remedy this by adding a few drops of liquid ammonia to a small pot of water, wash the surface vigorously and allow to dry. An old shaving brush is useful for this, and, incidentally, for a good many other watercolour purposes.

FRAMING AND MOUNTING It is necessary for watercolour paintings to be protected from injurious elements in the atmosphere, such as sulphur, especially in city areas. They should be mounted (matted), put behind glass and framed. A simple bevelled mount (matt) cut from chalkboard, a glass and backing board, enclosed in a narrow, plain oak frame (or plain oak rubbed over with whitening, called limed oak), is a useful standard enclosure for watercolour. See pages 106–7.

Working out of doors

SEATING When working out of doors, there is not always a convenient fence, rock, or felled tree on which to rest your paint box, water pot and sketch pad, or to sit on. A solution is to buy a small folding stool which can be carried in a brief, or similar, case. Make sure it is a strong stool. Get one just the right height for dipping into the water pot on the ground without having constantly to bend down. Use a briefcase or other flat case which will conveniently carry stool, two water jars, paint box, rag, brush holder, watercolour board, and paper or sketchbook. The covers of the sketchbook should be rigid. Use paper of substantial weight. When working outdoors put a bulldog clip at each of the two loose corners of the painting page, and a rubber band round the opposite pages and the cover. You will then have no trouble with the wind flapping the pages.

An old plastic raincoat is also a useful article of equipment. It too can be squeezed into the case. It is very convenient if a seat on a wall, or grassy bank, is wet from recent rain.

BOARD SUPPORT Rig up a board, with a couple of hooks screwed into the back of it positioned so as to fit snugly over the steering wheel of the car. This allows the painter to work in all weathers in reasonable comfort. There are limitations such as cramped space, and somewhat restricted view, but it is better than missing a promising subject because of rain or other impossible weather conditions.

In my experience watercolour painters are ingenious people. Many invent special items of equipment, some of which might well be adopted and marketed by artist's manufacturers. A support for a drawing board for outdoor work used by the eminent Yorkshire Dales artist, Fred Lawson, is illustrated on page 32. I am indebted to his artist daughter, Mrs Sonya Congo, for supplying this sketch which is self explanatory. Such a device gives the artist great freedom and flexibility of manipulation.

WEATHER AND TEMPERATURE Difficulties are experienced in extremes of temperature. *Landscape, Birkenhead* was produced in a temperature

A steering-wheel drawing board. The projecting strip attached to the lower edge of the board is useful for a spare brush or pencil.

A support for a drawing board for outdoor work. The main feature of this device is that the supporting leg is fitted with a metal ring with a point which screws into the back of the board. The artist sits and the lower edge of the board rests on his thighs. This allows a degree of movement and tilting.

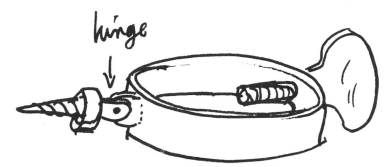

hinge

about actual size
made in brass.

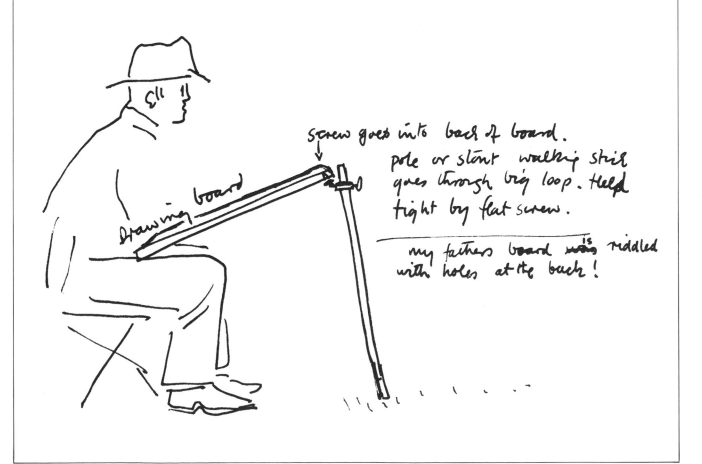

drawing board

screw goes into back of board.
pole or stout walking stick
goes through big loop. Held
tight by flat screw.

my fathers board was riddled
with holes at the back!

below zero. The washes froze on the paper. That was bad enough but, because the washes were frozen they could not dry. For such contingencies carry a small bottle of methylated spirits (denatured alcohol) and a shallow metal lid. Find a sheltered spot. Light a small pool of spirit and hold the paper over the flames.

Landscape, Birkenhead, a page from a watercolour sketchbook, 7 × 5 in. (17 × 12 cm) 'Not' white paper. The washes froze as they were applied and yet they did not smudge or run when they thawed out.

Extreme heat is even more difficult to deal with. It calls for much greater speed of working, otherwise very fast drying will result in hard edges everywhere. Reflected glare from white paper in strong sunlight is also a problem. It completely blinds the painter's vision except to black and white. The after effect on the retina of the eye is so powerful that it is impossible to see colour at all. My solution to this was to consult a sympathetic optician and obtain a pair of good quality sunglasses which are exactly neutral in tone, with no trace of positive colour. With these I can work in the sun. No adverse effect is observable in the colour of the finished work when it is later examined in a milder light.

Working in the studio

As you become more expert try working away from the subject, in the studio, using preliminary pencil and wash sketches. The studio provides controlled conditions, even temperatures, uncramped space, a desk or easel as a firm base for the drawing board (so leaving both of the painter's hands free), unlimited water, and appropriate light. This

33

View of Stoke-by-Nayland by John Constable (1776–1837). Watercolour, 5 × 7¼ in. (12.7 × 18.4 cm). This powerful watercolour has inherent strength which is achieved by simplification of the main masses, and by close integration of the composition. The effect is heightened by the dramatic use of contrasting tones.

suits some painters. But, remember, ease of working is gained at the expense of spontaneity. In the studio one misses the immediate contact with nature, the sudden magical effect, a change of light, a chance happening. All the same try working in the studio, it may suit you.

One more small tip. We have discussed above a 'kit' for painting watercolour out of doors. I like to keep my kit together in its case at all times whether I propose to paint indoors or outside. In this way I have a comforting feeling that I am ready to work, at a moment's notice, any time.

Styles

There are a number of ways in which the basic technique of pure watercolour can be varied. The most common are: the use of a pen line to add crispness and structure to the work (the method known as 'pen and wash'); the use of clear or coloured wax to vary the wash;

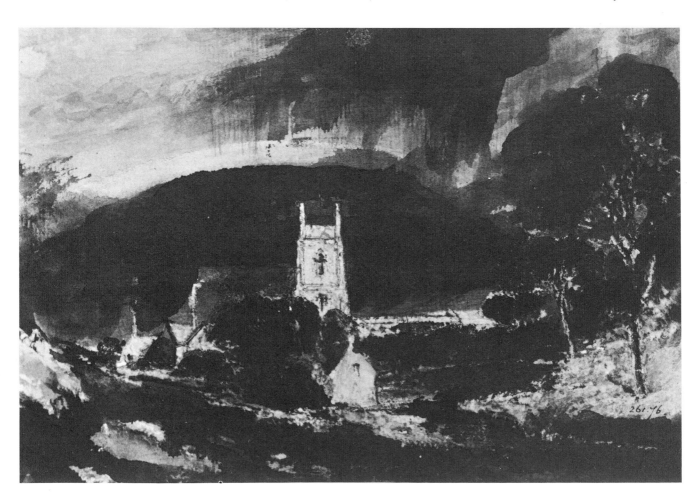

the use of white paint. But I take the view that if these are used they radically change the character of the medium, and so have no place under the pure watercolour heading.

The paintings listed below illustrate divergent styles developed by three eminent masters of watercolour but, first, refer back to the paintings of *Barges at Whitstable* by Wilson Steer illustrated on page 25. In that painting you see watercolour at its most economical and its most pure. Now compare the paintings reproduced on pages 26, 34, and 127. *The Terrace* (page 127) by David Jones, a master of the broken wash technique which he used with exquisite delicacy to produce magical, jewel-like, colour harmonies.

View of Stoke-by-Nayland by John Constable is the antithesis of the David Jones. Its essence is solidity and power in contrast to Jones' fragility. Constable makes a direct transcription of a dramatic mood in nature, whereas David Jones translates an aspect of nature in terms of his own poetic vision and unique personality.

Above Castle Bolton is by Fred Lawson, the Wensleydale master who should be much more widely known than he is. His consummate watercolour technique was secure and absolutely at his command. His knowledge of the Yorkshire Dales was complete. He was a poet and a philosopher. That beautiful part of England never had a more eloquent advocate than the limpid watercolours of Fred Lawson.

You now possess the basic information and equipment to go seriously into watercolour. You will have disappointments, and progress may sometimes be slow, but, if you work consistently, you will ultimately succeed.

2 Oils

The best watercolours are produced under tension; the tension of making exact calculations, precise strokes, and splitsecond timing. Oils, in many ways, call for quite different, sometimes opposite, techniques. Oils allow planning and thinking on a larger scale, freedom to manipulate the medium, on account of its slow drying, and virtually unlimited time to make decisions. In many ways oils are *easier* than watercolour, and yet one often hears such comments as, 'I'll try watercolour first and if I get on all right I'll try oils.' The implication is that one graduates upwards from watercolour to oil. The truth is that the oil medium is not more difficult, not easier, but different.

One similarity, however, is that it is possible, in oils as in watercolour, to make a start with minimal equipment. You will need:

1 Pigments.
2 A means of laying out the pigments so that they can be selected and mixed (a palette).
3 An implement to apply the paint to the painting surface (brush or knife).
4 A canvas or board on which to paint.
5 A device to hold the canvas or board while you are painting (an easel).
6 A place to work.
7 A piece of clean white rag.

The basic equipment needed for an oil painting is illustrated: a small tube each of black, white, ultramarine blue, chrome yellow, and alizarin crimson (the pigments); a piece of plywood cut from a tea chest (the canvas); one hog bristle brush size 7; one redundant dinner plate (the palette); and a piece of rag. The result of my first attempt at oil painting is illustrated on page 38. It is interesting to look at it again after a lapse of time. There is a good deal to be said for keeping your early works, however unsuccessful, and for bringing them out occasionally to see how you are getting on.

I learned a great deal from my first 'battle' with oil paints. I learned for instance that you cannot mix sympathetic greens from ultramarine and chrome yellow; that it is very difficult to make fine lines with a coarse brush. I found that paint applied thinly (I could not afford to use

It is possible to attempt a first oil painting for a very modest outlay.

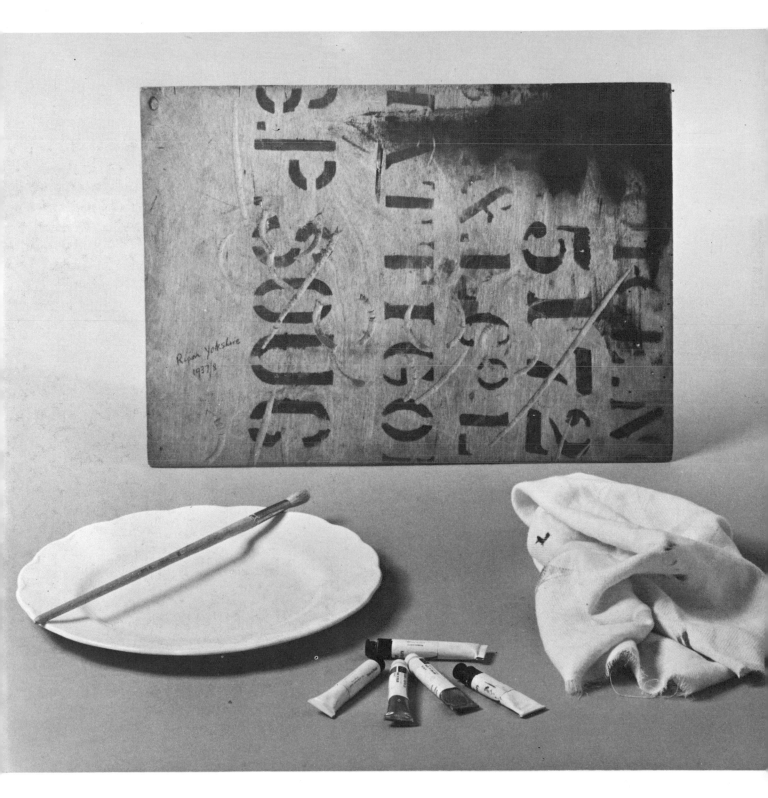

37

Ripon Cathedral, the author's first oil painting produced with the minimal materials indicated. Oil, 11½ × 15½ in. (29 × 41 cm). Painted on the reverse side of the board cut from the tea chest, this painting is now nearly forty years old and has been attacked by woodworm. The darkening of the oil film can be seen in places. The weaknesses in drawing, composition and brushwork are obvious.

it thickly) sinks into unsized wood. I discovered that what is a meaningful subject to the artist for personal reasons is not necessarily a suitable subject for painting. At that stage I had not encountered the concept that aesthetically it is not only valid, but necessary, if you are to retain the character of a subject, to vary and occasionally to distort details, during the process of transferring it to the canvas or board. I learned that I needed at least two reds, two blues, two yellows; that the paints used neat from the tubes were too thick. I needed something to thin them with. The proprietor of the art shop suggested linseed oil. I later learned that linseed oil by itself slows down drying and causes darkening of the paint film. Evidence of this can be seen top left of the illustration. I learned also that the most important consideration is a place to work. If you intend to take your painting seriously it is vital

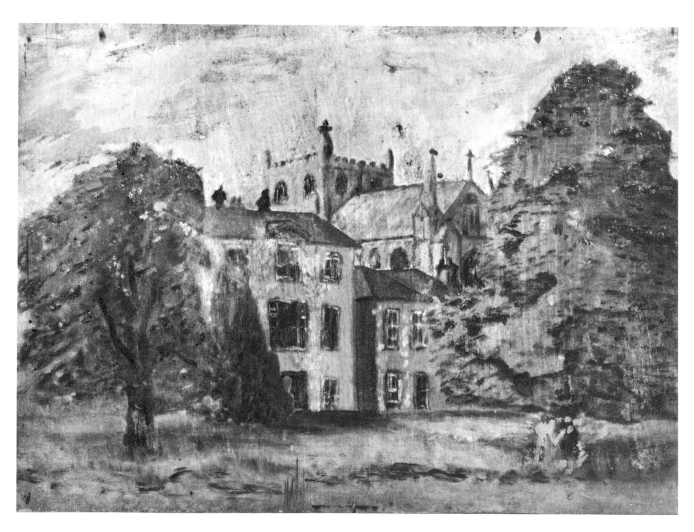

to have a room, or a corner of a room, or half a garage, a disused greenhouse, an attic, a space set apart where you can set up your work and leave it at the end of a stint, and return to it and begin work instantly, without frustrating delay.

Permanent equipment

Let us now consider the oil painter's requirements. There are two groups, permanent equipment and consumable materials. The following are the items which you will need every time you paint.

EASELS You can manage at first by using a dining chair with a tall straight back for an easel, or a pair of wooden stepladders with a nail in each upright, but in the end you must buy or make an easel which will allow the canvas or board to be moved up and down and to tilt backwards or forwards. In other words you will need one which will accommodate pictures of all sizes and will enable you to vary the angle of the tilt to avoid awkward light reflections. Make sure, whatever type of easel you use that it is *rigid*, and that it will hold hardboard panels, drawing boards, and canvases.

There are five main types of easel: rack easels, radial easels, homemade easels, box easels, and light sketching easels. The rack, radial, and homemade varieties are suitable for use in the studio. From experience I consider the light folding type to be unsuitable for oil work out of doors. It is too flimsy. The best for outdoor oil painting is a box easel. It is stable. It folds up into a compact form. It has an integral palette and the box contains brush, bottle, and colour compartments. It is also made so as to carry wet canvases or boards in almost complete safety. The four best varieties of easel are illustrated on page 40. Some artist's suppliers market a table easel. This can be very useful when space indoors is really tight. The box easel, with its legs folded away, serves perfectly as a table easel.

The box easel is therefore not only highly satisfactory for outdoor work but also for the indoor studio where it serves perfectly as a rigid studio easel which can be left in position or folded away. The box easel is not excessive in cost, being about the same price as a radial easel. But you could hardly take a radial easel sketching out of doors.

PALETTES If you buy a box easel it will include the palette. If you buy a separate palette you will have a wide choice of shape and surface, oval, rectangular, kidney-shaped, all in varying sizes and made from mahogany, plywood, or plastic. You could buy an offcut of any of these materials 24 × 16 in. (60 × 40 cm), draw your own choice of palette shape on it and get a carpenter to cut it out for you with a band saw.

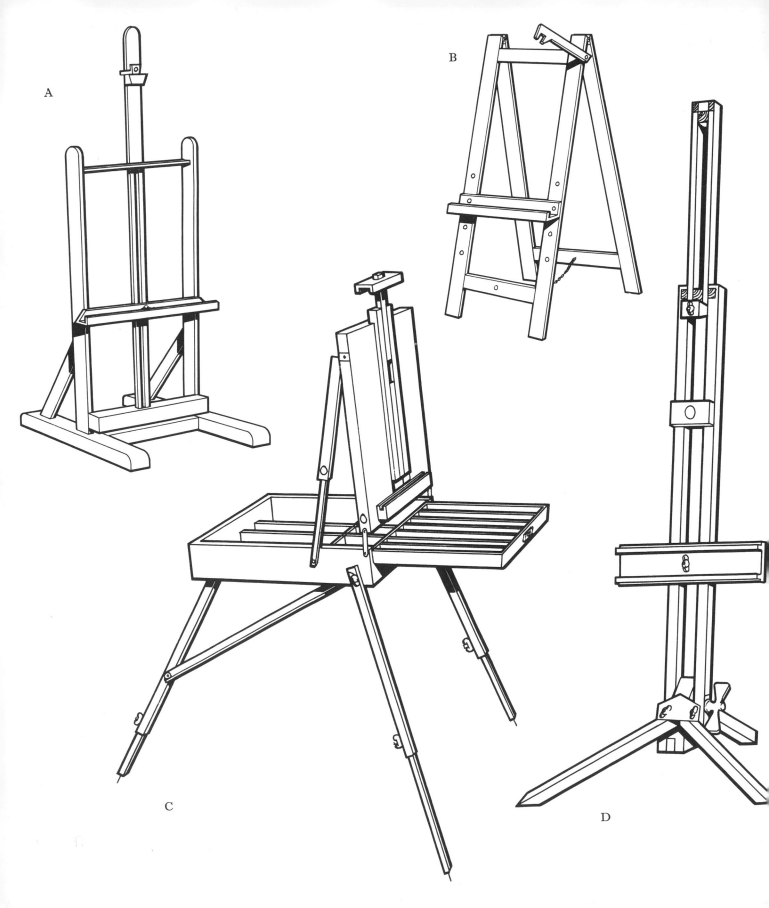

A

B

C

D

A traditional palette shape is illustrated. Make a grid of squares of the same proportion as that shown in the diagram, each square 4 × 4 in. (10 × 10 cm). Transfer the palette shape to the larger grid and cut out the outline. Use it as a template to cut out your palette with a keyhole saw. It will be much less expensive than a bought palette.

If you are a labour-saving person you can buy 'tear-off' palette pads comprising fifty sheets of oilproof paper. At the end of the painting session you simply tear off the top sheet and dispose of it.

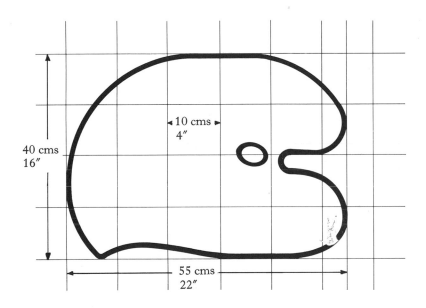

The rack and radial easels (A and D) have stability and variability of tilt, but are fairly expensive. A home-constructed easel (B) can be a good compromise. The best all round easel is a box easel (C): it is rigid, it will tilt and will serve equally well both indoors and outdoors.

PAINTING TABLE For indoor work there is a lot to be said for using a painting table. This combines a table palette with storage shelves. The one illustrated on page 42 was homemade. The table has the advantage of leaving both of the painter's hands free. Fitted with shelves and racks, it puts reserve stocks of paints, oils, and varnishes within arm's length. Also the painting table top provides a much larger and more stable mixing surface than the average hand-held palette.

DIPPERS (PALETTE CUPS) A small and inexpensive but indispensable item of permanent equipment is the tin dipper. The double type is the best. You can put medium into one cup and paraffin into the other for quick cleaning of brushes. For prolonged work in the studio keep a jar of paraffin for brush cleaning.

MODEL STAND The serious student whether amateur or professional is very likely to engage in some form of work requiring a model, animate

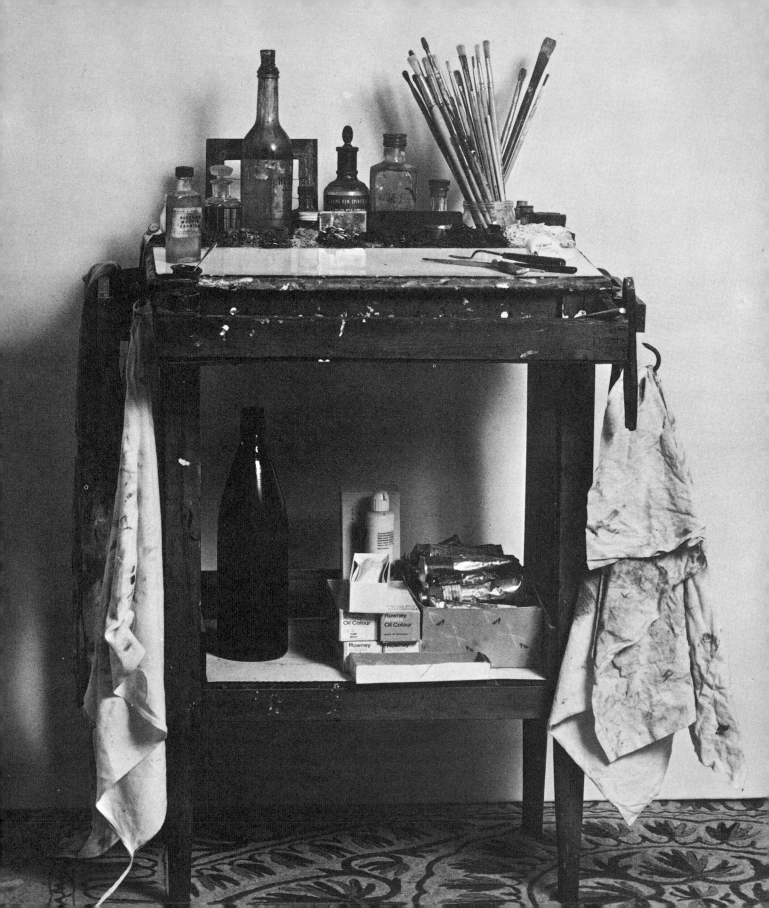

(*left*) The painting table.

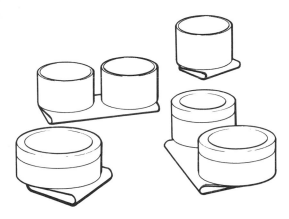

Dippers (palette cups) may be deep or shallow, with lid or without lid, single or multiple.

or inanimate, whether for abstract, still-life, or figurative painting. For this purpose a model stand is a great help. In my experience it is better to look down on subject matter while painting. Normal table height is too high (for my taste anyway). Secondhand furniture shops, and auction sales, often sell old kitchen tables at small cost. Cut the legs down so as to leave the table top 18 in. (45 cm) above the ground. Cover the top with attractive material of some painterly kind, and tack a skirting of the same cloth round the sides. A model stand is quite a major item, but with a bit of luck and ingenuity it need cost very little.

BRUSHES I am prejudiced about brushes, perhaps because I have used two particular kinds all my painting life. I never use any other than round hog bristle for oil. I keep about three each of sizes 2, 5, 6, and 8 in stock. With these and a knife I can do all I want to, except draw long thin lines. As there is often a need for thin lines, particularly in landscape, I keep in reserve a long-haired sable writing brush, sometimes called a liner or a rigger, size 4 or 5, or a lettering brush of the same size. These are extremely effective in oil painting when the subject demands delicate linear treatment.

Although certain methods and equipment work well for me, they may not for you. Think and experiment round the subject. For instance, I cannot bear the 'feel' of nylon brushes. You may like them. It could be argued that they are more durable and will stand rougher usage than other types. I dislike flat brushes and square-ended brushes. You may like them. The range available is quite wide. Try one of each and then stock up with the type you like best and give away those you do not like. Or use them for odd jobs. It is surprising how useful they can be for touching-up jobs in the home, and for dabbing oil on inaccessible bits of the automobile engine.

While painting I always keep handy, if working in the studio, a jar half full of paraffin; if working out of doors at least a large dipper of paraffin. This I use for washing my brush. I simply hold the bristles against the side of the jar or dipper, and twizzle it round between forefinger and thumb so that the bristles agitate themselves against the side of the container. As soon as colour ceases to float away from the bristles I squeeze them dry with a rag. I frequently use one brush only for a painting, washing it in paraffin between each colour application.

At the end of the session I wash the brush thoroughly in paraffin and dry it thoroughly on a rag. This process is frowned upon by the perfectionists, but I consider the time saved to be worth it. In fact, the paraffin treatment just described is only the first part of the total process. After rinsing with paraffin and removal of the surplus paraffin from the bristles, it is recommended that the brush should then be

washed in warm water with a good household soap under the running hot tap. Dry with a clean cloth and stroke the bristles into shape. I once asked a hardened old professional about this matter. I said I thought it was possible to be too fussy about things. 'Aye,' he said, 'you've only got one life!'

You must decide how you will deal with this matter. One thing is certain. Brushes are expensive. It pays to look after them.

As with watercolour brushes it is false economy to buy inexpensive oil brushes. Cheap types splay, and scratch, and in general feel disagreeable in use. The softer bristle types fold up and die. Good hog bristle are best. They have bounce, spring, and resilience. Get an illustrated catalogue from a reliable supplier and study the types available and sample them.

PAINTING KNIVES The brush is not the only means of applying paint to the painting surface. There is also the painting knife, not to be confused with the palette knife, though the palette knife is also used for the purpose. Various types of painting knives and two palette knives are illustrated. In general the blades of the painting knives are much more varied in shape, more flexible, and usually cranked. Palette knives have stouter blades, mostly more or less the same shape but varying in flexibility and thickness. I prefer one with plenty of pliability. I use both types of knife for painting. I use the palette knife for large areas such as backgrounds. I use the smaller, more delicate, knives for smaller work. I use knives quite as much as brushes. There are some effects which can only be achieved with a knife, the broader more

Painting knives.

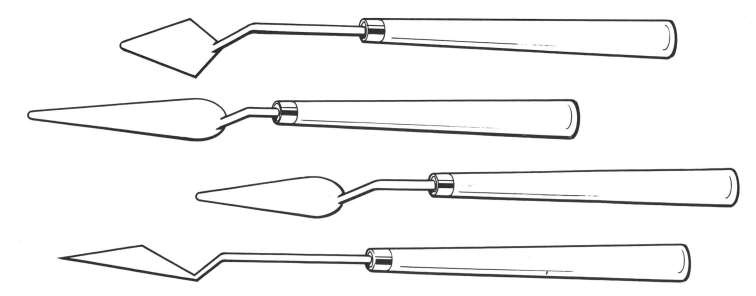

44

Palette knives.

vigorous effects. I will deal with this matter under the heading of brushwork.

SEATS When working in oils in the studio I keep a chair near the easel and painting table. When I am working on a picture I feel the need to stop work fairly frequently to contemplate progress. Sometimes the periods of brooding over the work are longer than the periods of active painting. I sit and let my eyes wander over and over the painted surface. Prolonged and probing looking is part of the painting process for me. Look long enough, and the work will suddenly reveal the next step to you. Then the next period of painting can begin.

For outdoor work provide a strong stool as for watercolour even though you think you may not use it. It is a matter of choice and habit as to whether you sit or stand. I usually stand, but I always carry a stool.

Materials

COLOURS All pigments are basically the same. The nature of the paints is determined by the medium they are mixed with. A blue pastel, blue poster colour, tempera, acrylic, oil, or any other, may all have the same chemical make-up. For example compounds of cobalt will provide a whole range of blues. The vehicle, diluent, or medium is what produces the varying characteristics.

As in watercolour start with a minimum number of colours. On page 38 I said I needed two reds, two blues, and two yellows. I would now positively suggest a beginning palette of crimson and burnt sienna for the reds, cadmium-mid and yellow ochre for the yellows, ultramarine and Prussian blue, burnt umber, black, and white.

In oils we do not have the problem, as in watercolour, of avoiding the use of white. In fact white is essential for virtually all colour mixing. There are differing opinions about the use of black. Some painters insist that all it does is to pollute the other colours with which it is mixed. I do not take this extreme view. In certain nonfigurative forms of painting black may be an absolute necessity. Some paintings may be carried out wholly in black and white. At the same time one must concede that

in certain circumstances Prussian blue provides a darker dark than black.

I include burnt umber because it is a stable earth colour. It is cheap and, mixed with ultramarine, it provides a wide range of sympathetic warm and cool greys.

Study colourmen's charts and catalogues. They make fascinating reading and most of them contain tables of the chemical composition of colours, and advice about judicious mixing, which are of considerable help to the painter.

The chemistry of pigments is an intricate branch of applied science. It is a complex subject even for the specialist. Nevertheless it is essential to know basic facts about, for instance, the permanence of colours, the incompatability of some pigments with others. There are three books which are standard works on the subject, one by Ralph Mayer, one by Reed Kay, and one by Hilaire Hiler (see page 148). The chemistry of oil colours is thoroughly covered in all of these. Every painter should possess at least one of them.

As an afterthought, do not let the advice about chemical composition and physical characteristics of colour given above inhibit you *too* much. For instance, I have used Prussian blue for years. It is considered to be dangerous and unstable. I choose the best quality and have suffered no disastrous consequences; though I do recall trouble with raw sienna in a still life I painted which was on show in an exhibition in Harrogate. It was one of my first still-life paintings. It contained late summer flowers, fruit, and vegetables. Imagine my surprise when I was asked by a friend, 'Did you *mean* to give those plums a crazy-paving effect?' I certainly did not. The cracking happened during the drying process. It was the result of the shrinkage of a mixture of raw sienna and alizarin crimson. The raw sienna holds a lot of oil. The mixture was used for the plums and the cracking was the result.

THINNERS AND DILUENTS Many artists use oil colours direct from the tubes. Most suppliers provide whites which are soft enough to make mixing easy, but mostly when using oil colours it is necessary to mix them with a medium to thin them down. The most common media are raw linseed oil and pure spirits of turpentine. Linseed oil used by itself retards drying and so slows down the pace of working. It darkens with age and imposes a gloss on the surface of the painting which can frustrate the viewer by causing annoying reflections. Turpentine, used as the only thinner, or painting medium, accelerates drying and imparts a matt surface to the work. It also gives off powerful fumes and so should not be used excessively in a confined space. Inhalation of turpentine vapour induces nausea which can sometimes be very unpleasant and prolonged.

I use a medium consisting of equal parts, by volume, of linseed oil and turpentine. I use the ordinary commercial varieties of both commodities. They are pure enough and are much cheaper than the artist's variety.

Some painters use varnishes as painting media. This procedure adds luminosity and gloss to the paint film. Try it, but be cautious. Paint plus varnish behaves differently from paint by itself. I would recommend that you keep to the established media until you have had time to make yourself fully acquainted with the differing properties of the various varnishes.

Detail from a still life showing the cracks which occurred during drying. It is better to avoid using pigments which absorb too much oil during the grinding process.

47

Suppliers also market other painting media which have specific properties such as quick drying, rendering the paint film flexible. These you may need from time to time.

THE SUPPORT The 'support' is the general term applied to material surfaces upon which the painter works. It may be made of canvas, hessian, burlap, canvas board, strawboard, hardboard, Presdwood, Masonite, oilpaper, wood panel, fibreboard, metal panel, glass, Essex board, or plywood. Compare the relative costs of the various types of support. There are considerable differences.

Whichever support you decide to use, remember that for oils it is necessary to prime the surface to make it nonabsorbent, or less absorbent, otherwise the paint will sink and a matt surface or a patchy surface – glossy in places and matt in others – will be the result. There is also another reason for priming. As linseed oil paint ages it tends to become translucent. A white priming underneath will tend to reflect more light back through the paint film, and so the risk of the picture darkening will be lessened.

Large cardboard cartons can be used to make modest sized practice boards for studies. Make sure the sides of the carton are made from solid cardboard. Cut the sides of the carton into neat rectangles, as large as the shape of the carton will permit, and paint the nonprinted faces with two coats of flat white undercoat paint. If you wish later on to preserve paintings done on cardboard they can be fixed to a rigid backboard: coat the back of the painting and one side of the backing board with strong adhesive and secure them under a heavy weight or in a nipping press.

Canvas and hardboard are the two most generally used supports, and of these hardboard is much the cheaper. When using hardboard, apply a minimum of two coats of good quality white-lead undercoat paint on the smooth side. The advantages of hardboard are, that it can be easily cut to any shape or size, it is durable, and is permanent. I prefer the rigid surface of hardboard to the pliant surface of canvas. Hardboard is less vulnerable to sharp projections and, one supreme advantage, it does not have to be stretched. I recommend it to all readers.

If you prefer it, primed canvases can be bought ready stretched on wooden stretchers, from 7 × 5 in. (18 × 13 cm) up to 60 × 40 in. (150 × 100 cm), in various textures and qualities.

Canvas is also available in rolls from 27 to 84 in. (68 to 213 cm) wide, either primed or unprimed. Wooden stretcher pieces can also be bought in sets complete with wedges. Stretching canvas is a simple process. Lay the roll on the floor. Unroll it to the required length. Lay down the assembled stretcher pieces, with wedges lightly fixed in place, on the

Different modes of application produce varying textures in the paint: (*top left*) the colour was laid thickly with adjacent touches placed at random; (*top right*) irregular, adjacent patches of paint were laid with the side of the brush; (*bottom*

canvas. Cut the canvas to a size which allows a 2½ in. (6 cm) excess all round. Re-roll the canvas roll. Overlap one edge of the cut piece and drive a tack in the centre of one of the short sides. Turn the stretcher through 180 degrees. Pull the canvas tight and overlap the opposite short side. Stretch it finger tight, or use canvas pliers to pull it tight. Drive in another tin tack. Treat the other two sides in the same way. Continue tacking, working outwards from the first centrally placed tacks. Check all the while that the canvas is as taut as you can make it and without wrinkles. Drive home the wedges with a light hammer and the canvas will tighten. Finally tidy up the corners.

Studies

Let us assume you now have ready for use a painting corner, an easel, a support, the minimum range of colours on a hand-held or table palette, a double dipper, brushes, palette knife, rags, a bottle of medium, and a model stand or table. With these let us try out some modest practical studies. Oil paint is an extremely flexible medium, so wide-ranging, in fact, that no two painters use the same combinations of technical possibilities. The way in which painters put the techniques together accounts for the recognizable personal styles of the different artists. You could never, for instance, confuse the styles of Vlaminck and Topolski. They are both immediately recognizable and nameable. Topolski uses a line approach, and Vlaminck used a fierce slashing palette knife and areas of intense colour. So I believe it is vital to gain firsthand practical experience of techniques. Let us begin with different methods of applying oil paint to the painting surface.

STUDY ONE: BRUSHWORK, AND THE USE OF THE KNIFE One of the main differences between the work of the experienced and the inexperienced painter is in the brushwork. The painter of longstanding develops a sort of handwriting in paint. So begin by mixing a quantity of colour of your choice and apply a series of patches on a practice board, each patch being applied with uniformity of handling. Note how the colour appears to vary. This is because the differing modes of application produce varying textures in the paint, and the differing textures react differently to light playing across their surfaces. The experienced artist exploits this phenomenon in every picture he paints. The four specimens illustrated here are intended to start you thinking and to encourage you to invent your own methods of brush and knife work. Try to avoid commonplace and unthinking application of paint, especially in backgrounds. The background, every bit of it, is as important as any other part of the picture. Poor brushwork shows!

(*left*) this effect was produced by repeatedly loading a palette knife with paint and applying it with a circular movement of the knife; and (*bottom right*) the area was filled with dots of paint.

A study session on this theme will add capital to your bank of experience.

Palette and painting knives are equally effective for *removing* colour. Some beautiful effects can be produced by laying on a colour and then scraping it away with a large palette knife. The residue left on the canvas frequently has exquisite quality. Discreet use of this process adds variety to your technique.

STUDY TWO: COLOUR Select one of the modes of brushwork from the preceding study as the method you are going to use for *this* study. Lay on the palette a good quantity of both the yellows, and of white and, say, ¾ in. (2 cm) squeezes of the other colours. Select a practice painting board of about 40 × 20 in. (100 × 50 cm). Now paint a patch of one of the yellows anywhere you like on the board. Place a small amount of the same colour on the palette and mix the smallest touch of, if you like, burnt umber with it. Mix it thoroughly and then transfer it to the study next to the first patch of colour which you put on. Note the subtle difference in colour caused by the mixing. Now go on and mix as many patches of slightly varying yellows as you can invent and place them side by side on the painting surface until it is totally covered and no white ground shows through. All must be yellow and every yellow must be different from all the other yellows. Do not try to be 'clever' about it. Vary the sizes of the shapes if you want to, but avoid exaggerated pattern making. Avoid too recognizable shapes. Treat the study as one of abstract colour and shape only. This study has a triple aim: (1) it tests and trains your ability to recognize subtle variations in one colour; (2) it gives you experience of colour mixing; (3) it provides practice in brushwork, or knifework.

The above study can be carried out many times using different colours; each will produce a panel of colour. Each version will vary, and in each case you will have produced an abstract painting. You may very well be surprised at the beauty of what you have done.

In the above study you invented the shapes. Another approach is to select or to abstract your shapes from nature. This is subtle and fascinating, and goes right to the heart of the creative process. It will add a 'fundamental' quality to your work.

STUDY THREE: TEXTURE; THE NATURE OF THE SURFACE OF THE PAINT (illustrated on page 54) Take another smaller practice board, say 20 × 16 in. (50 × 40 cm). With pencil and rule, divide it into twenty 4 in. (10 cm) squares. Use white direct from the tube. Cover one square with a layer of white oil paint about ⅛ in. (2 or 3 mm) thick. Take the brush, and instead of using the bristles use the wooden

The yellows study in progress: the painting is seen at a fairly advanced stage with the picture surface almost covered. This exercise will develop the ability to recognize subtle variations in one colour, as well as giving practice in colour mixing and brush or knife work.

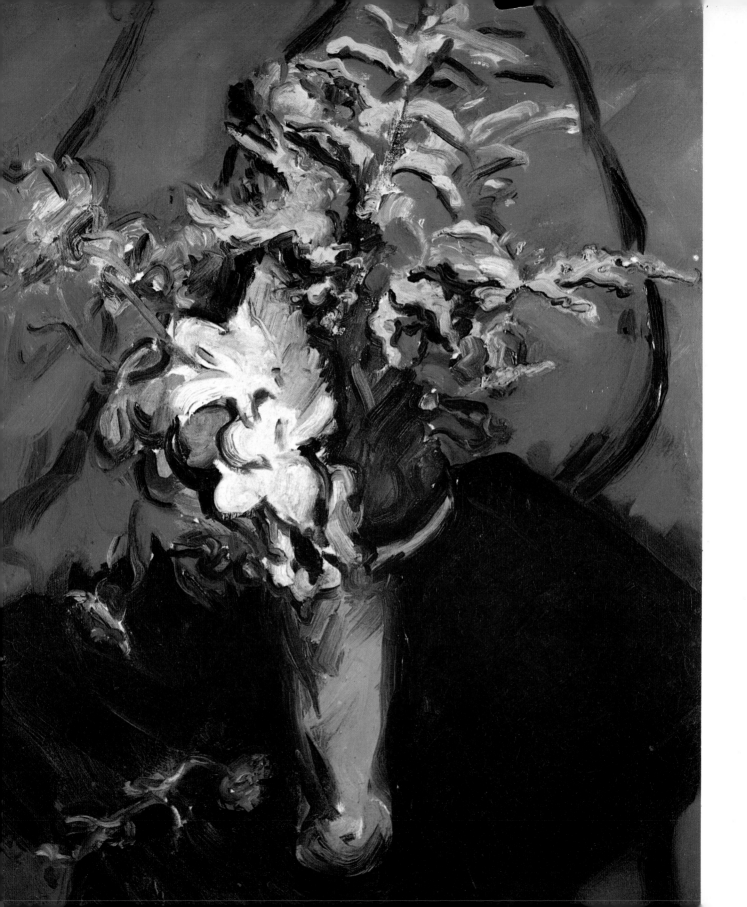

Golden Rod and Lilies by Matthew Smith (1897–1959). Oil, 25 × 19 in. (62 × 48 cm). Matthew Smith's 'handwriting' is vigorous and personal and a good example of the *premier coup* method. His brushwork is as passionate and as direct as his use of colour. He became famous for his burning reds. Some of his canvases have the quality of a conflagration of colour.

end and make a round-and-round scribble in the paint. Keep on until you have produced an over-all texture. In the next square stipple the paint surface with a drinking straw. You may need to use one or two replacements before you finish. Now use your powers of invention and produce a different texture in each square until all twenty are full.

I hung a study of this kind, framed in a lath frame (see chapter on framing, pages 106–7), and it was surprising how many visitors commented upon it and genuinely liked it.

Remember this study has a practical application when working on representational subjects later on. It is also designed to show that the brush and palette knife are far from being the only tools for applying and manipulating paint. But, if you use fingers, take care. Some pigments are toxic. Flake white is. So is any paint with a mercury base.

At the end of this study, once again, you will have produced an abstract painting.

STUDY FOUR: SCUMBLE It took me a long while to understand the reason why the paint surfaces of the great masters – Rembrandt, Bonnard, Vuillard, Monet – had such a magical appearance. Scumble is one of the reasons.

Scumble is the process of laying an area of oil colour, or a first grounding of colour, all over the picture, or parts of a picture, and then, when it is dry, or very nearly dry, of dragging another opaque colour over the top so as to leave flecks of the underpainting showing through. Imagine an all-over-alike blue sky underpainting, with a darker blue scumble scrubbed over the upper part, a lighter scumble over the middle, and a pale-greenish scumble over the sky near the horizon. Better still, do not imagine it, paint it as the next study. Visit the nearest gallery. Seek out an original painting which employs a scumble technique and study it.

Scumbling can be carried out with a brush, a knife, with the fingers, as a stipple, or with a small pad of rag. Scumble is a broad term and implies modification of a paint layer by the addition of a further opaque paint layer over the top. Sensitively used the scumbling process produces subtle enrichment and colour variations which are obtainable in no other way.

One word of warning; do not overwork the scumble with too many strokes, or the effect will become as dead as putty.

STUDY FIVE: GLAZING This is the opposite of scumbling. It is a process of modifying the colour or tone of the underpainting by applying a transparent layer, or film, of paint over it. The glaze should be prepared by mixing a transparent pigment with medium until it is a

P.P.A.— C

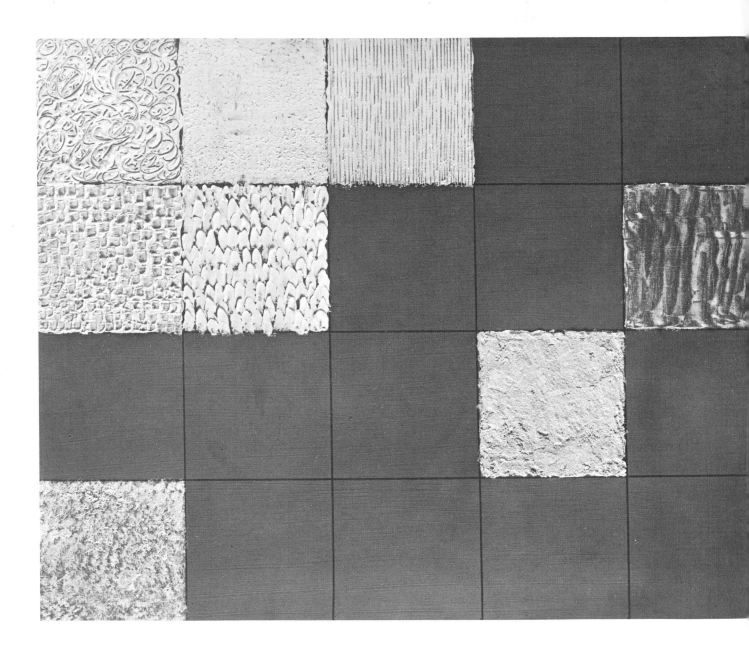

fairly heavy consistency. You will probably find it best to apply the glaze with a softer brush than a hog bristle, perhaps with a soft pad of cloth, perhaps with the fingers.

The effect of a well-applied glaze is to produce luminous colour. If the undercoat is lighter or more intense in colour than the glaze, it will glow through, because it will reflect the light through the transparent or translucent glaze, an effect that is only obtainable in this way.

A study in texture with white oil paint. Repeat the textures described on pages 50 and 53 or, better still, use your own powers of invention to produce a different texture in each square. The brush and painting knife are not the only tools for applying paint.

I am sure by now you will have thought out a series of glaze studies which you could try. For instance, lay out on a practice board patches of the six spectrum colours, red, orange, yellow, green, blue, and violet. Let them dry. Next mix two or three darker, duller, transparent glazes. Lay or rub or dab the glazes over the brighter spectrum colours, and see what happens.

Some intense colours in nature can only be rendered at anything like the same intensity by glazing. For instance, scarlet by itself will come nowhere near the intense red of the geranium, but if you lay a bright yellow undercolour and then glaze a rich transparent scarlet over, the intensity will be greatly increased.

Renaissance painters laid the foundations of their paintings in white, grey, and black, and then laid coloured glazes over the top.

Set up a very simple still life and paint it by this method. First make a monochrome underpainting in white, grey, and black. Complete it by laying coloured glazes over the top. All these studies will help to build up your technique, and will offer you the possibility of adopting the methods you like and of rejecting the others. Glazing over underpaintings is not without its dangers, as some of the cleaned pictures in public galleries reveal. During cleaning it is not unknown for a thin top glaze to be inadvertently removed, and for the character of the painting to be changed for ever. Even priceless Rembrandts have suffered in this way.

Finally, here is a useful tip relating to glazing. If you have produced a painting, and if, after living with it for a few days, you become aware of an area of colour within the picture which is too obtrusive, too bright or too light, its tone and/or its intensity can be reduced by rubbing over it a thin glaze of some neutral tone such as raw umber. Try a study of this by laying a strip of intense colour and, when dry, rubbing half of it down with a bit of raw umber on a pad of soft rag; note the difference in intensity between the two areas.

STUDY SIX: PREMIER COUP PAINTING *Premier coup* painting has already been mentioned several times in the chapter on watercolour. It is a method of painting in which the colour is laid in one stroke. It has great spontaneity and freshness. Nothing looks more dreary than tired paint. A system of laying colour with a minimum of 'working' is likely to preserve the liveliness of the colour. Van Gogh is a case in point. Select one or two simple subjects, landscape or still life, and try your hand at portraying them using one stroke only for each application of paint. Think hard and analytically first before applying each stroke. Stick inflexibly to the one-stroke rule and see how you get on. This study will lead to the creation of interesting paint surface qualities. I

find this the most fascinating part of painting. Oil paint can have a jewel-like beauty of its own. It is the complexion of the picture. Like most complexions it can be full of life or just plain dull.

STUDY SEVEN: STRAWBOARD AND TURPENTINE Toulouse-Lautrec, towards the end of his short life, developed a particular method of using oil paint. He took as his support unsized and unprimed strawboard or cardboard. He then worked rapidly with oil paint diluted to the point of extreme fluidity with neat turpentine. This called for great concentration and speed of working. This method is economical of paint and produces a surface of fine, dry, unreflective quality. So, for study seven find a piece of strawboard and try out this dry matt technique. It may suit your style of work.

STUDY EIGHT: DRAWING AND OIL PAINTING The basic difference between drawing and painting is that drawing is concerned with line, and painting is concerned with area or mass. In fact very few drawings are entirely line, and few paintings are entirely mass or area or patches of colour. However it is, without sound drawing, it is unlikely that the painting will look convincing.

It is necessary to develop techniques for drawing with the brush or other suitable tool. For delicate thin lines use a sable liner, or lettering brush size 4 or 5. First paint an area of colour on to a practice board. Let it dry. Mix a quantity of paint of the required colour, fluid enough to flow easily, but stable enough to retain its place on the vertical picture face without dripping down. Take your 'liner' and, if your stroke is to be up the picture surface, trail the brush after your hand. If you want to make a downward stroke, again, drag the brush after your hand. It is not possible to drive the bristles forward. The tip of the little finger should be kept in contact with the surface of the painting to provide stability. Stability of working is important, especially for small lines in the centre areas of large pictures. The mahl stick (illustrated on page 59) is an invaluable aid in this context. It forms a bridge – supported by the painter's non-painting hand and the slip-resistant pad – on which the painting hand can confidently rest. Actually any stick, so long as it is fairly rigid, and about 40 in. (100 cm) in length, will serve. The pad on the end is chamois leather or cloth stuffed with cotton wool and tied. Its function is to prevent slipping.

STUDY NINE: FINE WHITE LINES If you require fine white lines use a sharp metal point penknife or spike to scratch through the paint film and reveal the white underpainting. This type of line can be incisive, clean, and free from fluffs. Make a few experimental lines.

Jane Avril in the entrance of the Moulin Rouge by Toulouse-Lautrec (1864–1901). Oil, (strawboard and turpentine method) 40 × 21¾ in. (101 × 55.2 cm). The striations produce a sense of vibration and vitality.

(*left*) The effect of drawing with a fine sable liner and fluid oil paint over a dry, or nearly dry, oil paint surface. This type of work must be *premier coup*. Working over the line will destroy its freshness and spontaneity.

(*right*) The mahl stick provides a support to steady the painter's hand while he is working in the middle of an area of wet paint.

STUDY TEN: OIL AND PENCIL Try drawing on the dry paint surface with a well sharpened HB pencil. A few discreet pencil lines in a large oil painting are often helpful and merge well with the brushwork. In oil painting do not be too much of a purist. The end justifies the means.

STUDY ELEVEN: DRAWING INTO WET If you are working on a landscape out of doors, for example, you will need to draw into wet paint surfaces. Use the dragging technique as suggested in study eight, with a much lighter touch. Do not worry if breaks occur in the line. This may well be an advantage in giving an air of delicacy to the work. Do not attempt to patch the gaps. The Impressionists were masters of this kind of drawing. Take a look at some of their work.

It is also possible to draw into wet paint with the wrong end of a brush. All means are justifiable if the results are what you want.

STUDY TWELVE: BRUSH AND OIL LINES Take a practice board and a size 6 round ferrule hog bristle brush and see how many different types of line you can make with it. Try dragging the brush; try using the sides of the bristles; try stippling; try using the paint in various consistencies. Above all try to invent other ways of making lines with the brush. Produce a board full of different lines.

STUDY THIRTEEN: PAINTING WITHOUT PRELIMINARY DRAWING In the last four studies we have been discussing drawing related to oil painting. There is still a final question to be considered: should one draw the subject before starting to paint. Standard practice at one time was to lay in the main masses in outline, with charcoal. I find this unsatisfactory because, if the charcoal line adheres thickly, it can have the unfortunate effect of absorbing the oil from the upper paint film, and leaving a dry outline visible.

In my view, it is preferable to outline the main shapes in the subject with oil paint diluted with medium. This will then merge into the work as you go along. How and where you lay the main shapes is of vital importance to the end result of your work. Composition is part of the painting process in all media. We shall be taking a look at it in isolation, as one of the elements of art, on pages 138–40. I frequently use pencil to draw the main outlines. The general principles of drawing for painting are considered on page 113.

Whatever method you choose the important point to remember is that any preliminary drawing should be, as in watercolour, minimal, and should allow flexibility of working. If the drawing is too detailed it will restrict the painting process.

You should try at least one painting without any preliminary drawing of any kind.

STUDY FOURTEEN: SIMPLE STILL LIFE Take an apple. Place it on an off-white ground – a piece of newspaper, or white or cream-coloured cloth will do. Take a practice strawboard large enough to allow four paintings of the same apple. Work lifesize. With a pencil divide the board into four equal squares. Prime three of the squares and leave the fourth unprimed. In the first square paint the apple and its background using the study one techniques. Paint the apple again in square two but this time do it with the knife. Thirdly paint a monochrome underpainting first, allow it to dry, then add coloured glazes over the underpainting. On the fourth square, which should be bare cardboard or strawboard, try working by the Toulouse-Lautrec method (study seven), that is with colour very much diluted with turpentine.

This comparative study should be helpful in choosing *your* style.

Four studies of an apple: (*top left*) *premier coup* painting with a brush; (*top right*) *premier coup* painting with a painting knife; (*bottom left*) transparent glazes applied over a grey monochrome underpainting; (*bottom right*) oil paint, diluted with turpentine, on strawboard.

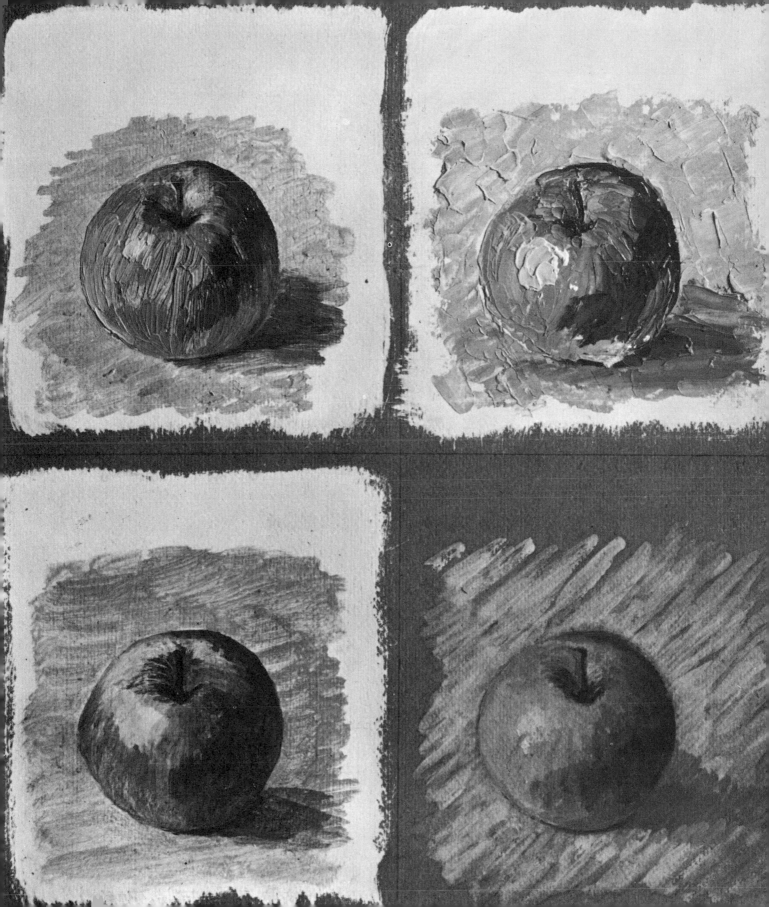

If you have worked at all the studies suggested you will now be impatient to move forward to more sophisticated subject matter, but, before you do, take a look at the section Motivation in the chapter 'The painter's vision', and Composition in 'The elements of art'. These are designed to help you to uncover, for yourself, your own special aptitudes.

PLANNING The oil medium is in many ways a more accommodating medium than watercolour. Mistakes can be rectified by scraping out and repainting. But beware of too much overpainting. If overpainting is intentional as when glazing, well and good, but if it is only a cover-up measure to hide mistakes the paint surface will quickly begin to look 'tired'. Plan your work carefully in advance. Make up your mind what you are going to attempt, and do it with as much *premier coup* work as possible. Let your brushwork, or knifework, be clean and direct. Resist the temptation to 'fiddle with it'. Especially, beware of the temptation to go on and on. More paintings are ruined by too much painting than by too little. Knowing when to stop is part of the planning process.

The enlarged palette
Now that you have tried out the various studies and are about to embark upon more ambitious work we must consider what additional colours you will need.

It is still advisable to keep your palette to a moderate size. I suggest:
Reds Alizarin crimson, cadmium scarlet, burnt sienna, Indian red
Oranges Cadmium orange, chrome orange (if of good quality)
Yellows Yellow ochre, raw sienna, lemon yellow, Naples yellow, cadmium yellow (mid)
Greens Terre verte, viridian
Blues French ultramarine, Prussian blue (good quality), cobalt blue
Brown Burnt umber
Black Ivory black
White Flake white

This palette is suitable for oil, gouache or acrylic colours. It is an all-purpose palette which will give you virtually all you need. I would recommend that you buy artists' quality for all serious work.

Some colours are less expensive than others. Chrome yellow for instance is much less expensive than cadmium yellow. Scarlet lake is less than cadmium scarlet. If you buy the best artist's quality and mix them judiciously, the cheaper pigments, in that range, are reasonably safe. For trial work and minor studies, student's quality pigments will serve. All the earth colours are safe in student's quality.

In the end, however, you will be well advised to adopt a palette

which you know from experience to be reliable and permanent. Every pigment has its own particular characteristic. Sometimes even the same pigment produced by different makers, has different qualities. It is only by continuous use of the same make of pigments that you can come to know exactly how they will perform.

Artist's pigments are not cheap. A good rule of thumb is to buy all your earth colours, i.e. burnt sienna, yellow ochre, raw sienna, terre verte, burnt umber, in student's quality, because they are safe permanent colours, and buy good quality artist's varieties in the other colours. You will find that you do not use so much of the crimsons, the scarlets, the cadmium yellows, the oranges, and the viridians.

VARNISHES When you have completed some studies you may want to experiment with varnishes. There are a number, and they serve various purposes:
1 For brightening up passages of paint which have become dull because they have sunk into the painting surface. This is best done with a retouching varnish.
2 For putting a transparent protective film over the paint surface to keep out harmful elements in the air, for instance, sulphur in city atmospheres.
3 For giving extra 'depth' to the colours. Sometimes this has the unfortunate effect of causing unwanted light to reflect from the surface of the painting.

It is necessary to allow paintings to dry for a minimum of six months before applying varnish. Twelve months is a safer period. The reason for this is that the paint film shrinks, rapidly at first, more slowly after six months. If the varnish is applied too soon crazing and cracking may occur in the varnish film.

Remember that some varnishes are irremovable once they are applied.

Some varnishes tend to crystallize and so become opaque.

When varnishing a picture, work in a warm room. Use a soft, clean brush. Make sure you do not expose the wet, newly-laid varnish to draughts of air or it may 'bloom', i.e., a semi-opaque, grey-blue film may form on the surface, dry that way, and so obscure the painting. Consult your dealer about the properties of the varnishes he offers.

We have now discussed the various grades of oil paints and the main techniques of applying them to the varying types of support. We have concentrated on the different modes of painting, *premier coup*, glaze, scumble. We have in fact taken the first steps in practical oil painting. You are now ready to launch out on your own in that direction which seems most natural to you.

3 Gouache

Gouache is a somewhat vague term. Your art store will supply you with gouache colours as such. If you go into a child's junior school virtually all the paintings on display will be gouache, painted as they probably will be with powder colour. Fashion and poster artists use gouache colours. It is equally a valid medium for fine art. The best general definition is that gouache is any pigment ground in water, gum arabic, and precipitated chalk. The combination of chalk and gum renders the colour opaque, and this opaqueness is the medium's main characteristic, in other words, its strong covering power. One could describe gouache as halfway between transparent watercolour and oil paint. As with watercolour it is convenient to use, and it has something like the robustness and density of oil colour.

Materials and equipment

THE PIGMENTS The best quality gouache colours are finely ground. They have intense covering power and spread smoothly. The other varieties are less sensitive. They are not so smooth and delicate in use, but are basically the same pigments and produce almost identical effects. There is one characteristic they all share. They all dry lighter in tone than when they are applied wet. This must be taken into account when working.

The pigments are sold in various forms: designer's gouache, moist, in tubes (the best artist's quality); designer's poster colours, moist, in jars (good quality); powder colours, in dry form (school and student's quality); powder colour, compressed into cakes or blocks (school and student's quality). Some artist's suppliers offer powder colour as a ready-mixed liquid paint (school and student's quality).

THE SUPPORT The surface upon which the gouache is to be painted can be paper of various kinds, and also a variety of boards. Usually a smoother paper than that used for transparent watercolour is found to be best for gouache. In transparent watercolour a white paper provides luminosity by allowing light to reflect back through the paint film. A white ground for oils will help to avoid darkening of the picture with age because, as well as darkening, the paint film becomes more transparent, and the increasing transparency allows the white ground

to reflect through more effectively. Gouache, however, is an opaque medium and the colour of the ground is not critical. This is not to say, however, that the colour of the ground is unimportant. If the mode of painting is a solid covering then the ground is totally obscured. Many painters use a rapid loose-stroke, crosshatch technique with the calculated aim of allowing the colour of the support to play a part in the final colour harmony. If striations of background colour lace through the painting it has a unifying effect upon the colour scheme. Look at the work of Toulouse-Lautrec for examples of this effect. If this loose technique is used, a variety of lively effects can be planned with the colour of the support in mind. This being so, it is a short step to using a white support and colouring it with watercolour to aid the finished effect, and then working in gouache over the top.

Gouache has a tendency to flake if applied too thickly so there is a good deal to be said for using a stout support or, if the painting is done on thin paper, for mounting it on a stout support.

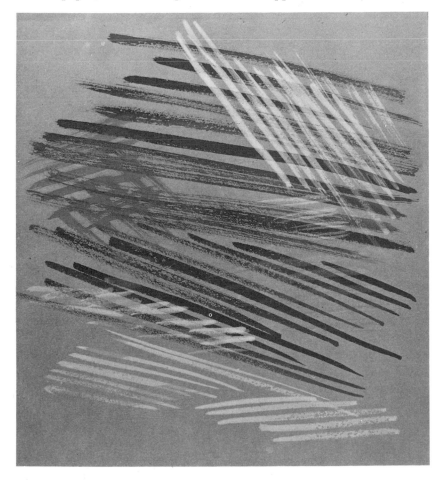

An exaggerated form of crosshatching, which shows the effect of one layer of striation on the layer above and below it, and the effect of the ground on all three.

BRUSHES The type of brush you use will be dictated by your style of work. If you are the passionate type who works vigorously, you will need a firm resilient brush, a soft hog bristle, round ferrule, say, size 8. If you are a more contemplative painter, and like to work more slowly, a size 3 or 4 good sable, a couple of oxhair brushes, size 6 and size 12, and a smoother paper will probably suit you better. As always, you will find out what you want as you go along.

PALETTES In this age of synthetics the biggest selection of palettes is available in plastic materials. They look something like cake tins with four, six, nine, or twelve wells. They are inexpensive and efficient. The china variety are still available; they appear in art catalogues under the general heading of chinaware, and comprise round and square tiles with slanted divisions. Do not forget the old standbys, redundant dinner plates and enamel plates. They make satisfactory palettes and can be immersed in water for easy cleaning.

ANCILLARY EQUIPMENT You will need a good sized drawing board say size A1, approximately 24 × 34 in. (60 × 85 cm). Gouache as a medium generally promotes larger work than watercolour. One or two screw-top jars will be useful, as will quantities of clean rag, and you will, as for other media, need somewhere to work. Finally add a dozen or so double-headed drawing pins (thumbtacks) to make life easier when attaching or detaching work to or from the drawing board.

MINIMUM PROVISION FOR GOUACHE A simple basic trial provision for gouache painting is a fitted box of eight to ten tablets or cakes of opaque colour, with integral small palette and, say, a size 6 oxhair brush; water jar; cardboards of various textures, cut to, say, 24 × 18 in. (60 × 45 cm) from packages and containers; two or three tinted fashion boards; two or three strawboards; a sheet or two of cartridge (drawing) or other paper; and a few sheets of scrap paper will be useful.

An alternative to a fitted box could be six or eight pots of poster colours. They are sold in paste form in $\frac{1}{2}$ oz (14 g) and 1 oz (28 g) sizes. They are reasonably inexpensive and a good range can be seen in most art shops. One word of advice, keep to the basic palette, as for oil paints. A colourman's catalogue will list burnt sienna, burnt umber, crimson, Prussian blue, raw umber, scarlet, lemon yellow, ultramarine, white, yellow ochre, and black. You could easily pick a minimum palette from these. The other colours listed are fancy names which might mean anything in the way of chemical make-up. Many of them may well be fugitive. It is by far the best to play safe and use only the pigments you know.

FULL PALETTE Choose your eventual full palette from: alizarin crimson, cadmium scarlet, burnt sienna, Indian red, cadmium orange, yellow ochre, raw sienna, lemon yellow, cadmium yellow, Naples yellow, terre verte, viridian, French ultramarine, Prussian blue, burnt umber, ivory black, white. As you will see, this list, taken from the best quality gouache catalogue, is more comprehensive and specific than the list above.

If, as time goes on, you need additional colours not included in the gouache list I advise you to buy tubes of watercolour and use them with gouache white; always, of course, remembering that once you *have* used them with white they are bound to be contaminated to some degree. Thereafter keep these aside for use with gouache only. Any trace of white will ruin the transparency of pure watercolour. The use of the term 'crimson' may mean a number of varying chemical combinations. Alizarin crimson means a basic pigment.

When using gouache as a fine-art medium, and not just for ephemeral work, you will do well to work, by trial and error, towards setting up a reliable, compatible, and permanent 'team' of colours.

Characteristics of gouache

Gouache is a flexible and accommodating medium which encourages experimentation and mixing of media. Great variety of effect can be achieved by choosing different coloured grounds or by using other media such as watercolour, pastel, acrylic wash, to vary the colour of the grounds.

Gouache covers well in all grades. It can be used thinly or thickly, always bearing in mind that a too thick paint layer may flake. The addition of a little PVA (polyvinyl acetate) or acrylic medium to the water jar while painting will render the paint film waterproof and may also give added luminosity. It would be wise to test a mix of high-quality gouache with PVA medium just to make certain that they are compatible. Do this before you use added media extensively.

A disadvantage of gouache, and its humbler version powder colour, is that the colour dries lighter than when it is applied wet, though the addition of small amounts of PVA, acrylic or polymer media, as suggested above, may lessen the lightening effect.

In addition to using other types of pigment to vary the colour of the ground, other modifications can be introduced while work is in progress by the use of watercolour, pastel, charcoal, pen line, Indian ink, pencil line, fibre pens, powder paint. An example of a mixed-media gouache painting by Norma Jameson is illustrated on page 68.

The section which follows suggests studies and experiments which will help to familiarize you with this attractive medium.

Dock Leaves by Norma Jameson. Coloured ink and pastel on a basis of dilute gouache, 30 × 22 in. (75 × 55 cm). Gouache is a flexible medium which encourages experimentation and mixing of media.

Studies

Compared with the variety of glazes, scumbles, knifework, and brush treatment in oil painting gouache has not so many specific techniques. Where there is variety in gouache it lies in imaginative combinations of the basic, and allied, materials of the medium.

STUDY ONE: PAINTING SURFACES Procure a variety of cardboards and papers, scrap material, brown packaging paper, coloured papers. Cut them to reasonably comparable sizes, say, 12 × 10 in. (30 × 25 cm), and paint layers of gouache on each. Colour is immaterial. Let some be flat, all-over smooth washes, let others be cross hatched, loose, open strokes. The object of the experiment is for you to physically feel the process of brush and paint passing over the painting surface. You will find some supports will feel satisfying, others will rasp, or skid, or absorb the colour too quickly. Decide on the support you prefer, by experience.

STUDY TWO: COMPARATIVE STUDY This is an extension of study one. From the same collection of papers and cards cut out twenty-five pieces, each 4 × 4 in. (10 × 10 cm). Gum them neatly on to a firm hardboard, or other similar, 20 × 20 in. (50 × 50 cm). It will hold twenty-five squares when full! Try to make sure that there is a good variety of surfaces such as strawboard, white card, cartridge (drawing) paper, smooth paper, brown paper, coloured paper. If possible let each of the twenty-five squares be different. Now mix a sufficient quantity of any colour of your choice to cover all twenty-five squares. Now, with a variety of brushes, hog bristle, oxhair, sable, and as many other ways of applying the colour as you can think of, sponge, paper stub, pad of cloth, cover all twenty-five squares. Use a different technique for each, keep neatly to the outlines, and use the same colour for all. When the study is complete and dry, observe it closely. Note differences of colour, of texture, of surface quality, of variety of effect produced by the different techniques. Make a mental note of those which give, in your opinion, the best effect or the effect *you* like best.

STUDY THREE: USING DRY POWDER COLOURS Take a sheet of paper and a tin of powder colour. With a wooden spatula, spoon, or paper scoop, place a small pile of dry powder colour in one corner of the paper. Take a brush, dip it in water, introduce it into the pile of powder colour and work it until all is wet and spread out. That is one way of applying powder paint. Repeat the process but this time when it is half spread take the spatula and drop a smaller quantity of a different colour into the middle of the wet patch and mix it through. That is

another way of mixing powder colour, i.e. using the painting surface as a palette.

Next take a palette, shovel some dry powder colour into one of the wells, add a small quantity of water and mix until it is of a creamy consistency. Apply the mixture to the paper. Without delay repeat the mixing of another colour in another well, and then, painting wet into wet, mix the second colour with the first which is now on the paper.

These are the two standard procedures for painting with powder colours.

On occasion you may wish to use large quantities of colour over a short period. If so, fill medium size screw-top jars with powder paint ready mixed with water to a creamy consistency, and store these ready for use. This procedure is recommended only if the colours are to be used soon after mixing. It is not satisfactory for long periods of storage. Some makes decompose and generate offensive smells.

N.B. Always add water to paint, not paint to water. It is much easier to gauge consistency that way.

N.B. It is perfectly safe to add PVA or acrylic medium to powder colour mixtures, say a teaspoonful to a pint ($\frac{1}{2}$ litre). The addition will result in a much more luminous painting. It will also be waterproof.

STUDY FOUR: ADHERING POWER By now you will probably have decided upon a palette which suits you, and a support which suits your needs, and you will have got together a collection of tubes, pots, or cakes, of colours which satisfy your aims. Before you commit yourself to serious work you should test the adhering power of the paint. Lay patches of different consistency colours on to samples of the supports you have chosen, and bend or roll them to see whether the paint layer cracks or scales. If it does, consider all aspects and try to decide why it cracks or flakes. Rethink your technique so as to avoid the trouble. Do not run the risk of breakdown after completion of a work. Purchasers have a right to expect paintings to last for a reasonable life span.

STUDY FIVE: MIXED MEDIA Purchase a small box of pastels. Take a modest sized sheet of paper. Paint a transparent watercolour wash on it. Run the pastels through the wash while it is wet. It will be found that the pastel will combine with the wet wash and can be worked at will. Student's grade pastel is quite good enough for this study. The effect of it is a gouache effect. Let the wash dry and experiment with pastel on dry wash. Work into the lines and patches you have already laid on the paper. Add a patch or two of gouache. Observe interactions and consider possible future uses. Try laying a thin wash of gouache over part of the surface.

STUDY SIX: CROSSHATCH AND COLOURED UNDERCOAT Lay a watercolour wash of one colour all over the paper or card. Let it dry. Mix a single colour gouache wash, make a vigorous crosshatching over the colour, and observe the effect of one upon the other. Make the crosshatching with as many different brushes as you possess.

STUDY SEVEN: SIMPLE STILL LIFE Translate the 'apple' study described on page 60 into gouache terms. Apply gouache study three to the production of an apple. Now do the same with gouache study five, and gouache study six. Combine two or more gouache techniques to make a statement about the apple, its form, its colour, its weight, its texture, its 'personality'.

4 Polymer

Synthetic plastic polymers were first produced by Otto Rhom in Germany in 1911, and were first made available commercially by Rhom and Haas, and by Dupont de Nemours in the United States of America, in the 1930s. The artist of today owes a great deal to industry and science whose joint efforts in the field of research into plastics have produced an entirely new range of paints which have many advantages over the old historical, time-tested, traditional types. (There are some disadvantages too, extremely fast drying for instance, but there are many more good points than drawbacks.)

Transparent watercolours are ground with water and gum arabic. Gouache colours are ground in water, gum arabic, and precipitated chalk or other opaque white. Oils are ground, generally, in linseed oil or other vegetable oils. Polymer colours, the latest addition to the family of artist's colours, are in most cases the same pigments, certainly the same inorganic pigments, dispersed in plastic emulsions made from synthetic resins such as the acrylics or the vinyls. The polymers and acrylics are still new enough for their characteristics to be unfamiliar to many users.

The nature of polymer paints: pros and cons

Perhaps the most outstanding characteristic of the new colours is their versatility. They can be used thinly in the manner of transparent watercolour, and the result is difficult to distinguish from the traditional form. Can you tell which is the polymer and which the watercolour in the illustration? They can be used as gouache, with the added advantage that they produce a non-flaking, flexible, paint film and, unlike gouache, they do not dry lighter in tone. Wet or dry the tones remain the same. They can be used for all the usual oil techniques, i.e. heavy impasto painting, glazing and scumbling, underpainting, overpainting. They are permanent. They are brilliant. They have great adhering powers. The organic pigments used in oils and other media are sometimes fugitive and often unstable and cannot be used in polymers, but to compensate for this the scientists have produced a series of synthetic organic colours from, for instance, quinacridone, phthalocyanine, naphthol, and azo dyes, which are excellent substitutes, and which are permanent under normal conditions of light and atmosphere. The

Polymers can be liberally diluted with water and used in the manner of transparent watercolour. Compare this use of polymers in *Railway Bridge, Stoke-on-Trent* (*top*) with the watercolour *Two Red Herrings* (*below*) and the intensely colourful polymer, *Farm*, reproduced on page 101, where a modified oil technique was used.

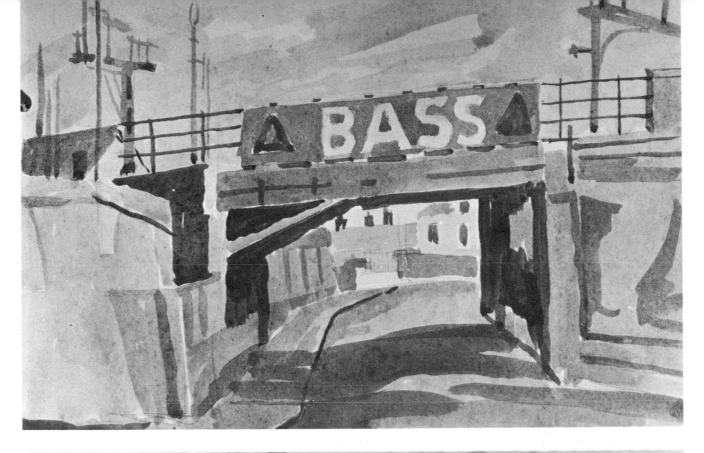

polymer paint film does not darken or yellow with age. Polymer colours can be used as watercolours on cartridge and drawing papers.

Polymer's quick drying is, at one and the same time, the quality which most attracts and most discourages new users. The paints are so quick drying that it is totally impracticable to lay out the palette as you would in oils. It is necessary to keep tops on tubes while working (special slip-on plastic tops are available) otherwise the paints harden in the necks of the tubes and the paint is trapped inside until the neck can be unblocked. There is a real danger that whole tubes may be lost. This is seen as a limiting factor by some painters though it does not worry, so much, the painter who has been accustomed to use oils in a *premier coup* manner. However one looks at it, it calls for modifications in technique, and established habits die hard. Some painters are irritated by these restrictions.

On the other hand the advantages of quick drying are obvious. One can lay an undercoat, immerse the bristles of the brush in a jar of water, and take a break. By the time you are ready to start work again the undercoat is dry and you can go on to the next stage of the work. In other words the whole painting process can be greatly speeded up.

An advantage of polymers is that they can be used for mural painting. They can be used on new and unprepared plaster for wall designs. Another useful quality is their adhesive power. Spectacular 'collage' techniques are possible, using the paint alone as the adhesive.

Make a solution of polymer medium (25 per cent medium to 75 per cent water, by bulk) and use this as a fixative for most drawing media.

If a polymer painting is carried out on canvas the picture can be rolled up as soon as it is dry and there is no risk of it cracking or peeling. In addition to being flexible the colours are stable and they do not craze as some oil colours do, if inexpertly used.

Polymers allow no leeway in timing. At the end of the work session, palette, brushes, and knives must be cleaned and any accidental splashes must be removed, immediately. Delay as little as two minutes and it may be too late.

POLYMER PIGMENTS Most artist's colourmen supply trial sets of polymer colours at reasonable prices which contain six or so small tubes and some medium. These are excellent for providing an inexpensive way of trying out this new range of colours. If you like them then make your choice of a fuller palette from: crimson arylamide or alizarin crimson, cadmium scarlet, burnt sienna, Venetian red, cadmium orange, yellow ochre, raw sienna, lemon yellow, cadmium yellow, Monastral green, ultramarine blue, Monastral blue, burnt umber, ivory black, titanium white.

These pigments are supplied in at least three consistencies: (1) fairly solid in tubes (artist's quality); (2) acrylic or polymer in tubes (designer's gouache); (3) more fluid type in tubes and plastic canisters.

You can make your own polymer paints by buying dry artist's quality powder pigments and PVA medium (Rhoplex in the United States), and by mixing them in glass jars. Mix 50 per cent powder colour, 25 per cent PVA medium and 25 per cent water, by bulk. Stir all together thoroughly. This provides a good workable paint.

POLYMER MEDIA Polymer colours dry extremely rapidly, indoors in about twenty minutes and outdoors much more quickly. When they are completely dry they are insoluble in water and cannot be reconstituted into paint. This one characteristic alone means that the painter using polymers must radically rethink his painting technique if he has become accustomed to the slow drying times of oil paints.

There are occasions when it is necessary to slow down the drying times, in very warm weather for instance. This can be accomplished by spraying with water. If a longer delay is necessary then use a 'retarder'. All manufacturers supply these, and the mode of use is to add about six drops of retarder to a 1 in. (2.5 cm) worm of colour and mix on the palette before applying.

In addition to the retarders, the colourmen also supply a variety of other media for use with polymers:

1 Gloss medium, which gives extra brilliance to the final picture surface. Mix/dilute with water. Supplied in plastic squeeze bottles. This can be used as a varnish.

2 Matt medium, supplied and used in the same way as gloss medium.

3 Glaze medium. Mix ten parts medium with one part polymer colour to provide a glaze. This medium can be used to size or prime a canvas.

4 A polymer extender, for building up heavy impasto textures. It dries hard very rapidly. It is extremely adhesive. Known as texture paste, this medium is valuable for modelling, for repairs to picture frames, reliefs, and casts.

Finally, not a medium, but a useful substance to know about, polymer primer for priming boards and canvases, which contains polymer emulsion and titanium white pigment.

Remember never to use turpentine or linseed oil with polymers; they are incompatible. The various manufacturers do not always use the same materials to produce commodities which bear the same or similar names in the catalogues. This could mean that some makes of polymer colours will be incompatible with others. A simple example of incompatability of two plastics happened on my writing table recently. A plastic eraser was left for some days in contact with a plastic ball-

point pen. When next I used the eraser I found that the two had coalesced. In fact the plastic pen had been eaten right through.

To be on the safe side, decide upon one make of polymer colours and media, and keep religiously to that range only; do not mix makes. In this way you will avoid the risk, slight though it is likely to be, of disastrous interactions between incompatible substances in both paint and media.

SUPPORTS A significant advantage of polymer colours is that whether you use the acrylic or the PVA type they can be painted directly, without priming, on to most supports. Suitable examples are all varieties of card, paper, board, canvas, hessian, burlap, Masonite, hardboard, Essex board, fibreboard, chipboard, newspaper. Virtually any surface is usable, with one reservation. The surface must not be oily or greasy. If it is the paint will not adhere securely enough. It is also wise to avoid excessively hard, smooth surfaces such as plastic, polished metal, or glass. A slightly absorbent surface is best. If you wish to use a *very* absorbent support then play safe and coat it with a layer of acrylic primer, and, depending upon the nature of the work, a layer of titanium white as well, if extra brilliance is required.

Permanent equipment
The equipment for polymer painting is basically the same as for oil painting (see page 39): you will need a place to work, easel, palette, model stand, brushes and knives, and a seat. Dippers are not necessary because the media, being so quick drying, evaporates. A drawing board, and perhaps a table easel, will be necessary if the polymer colours are going to be used thinly as in watercolour, or in the style of gouache. A useful extra is a spray of some kind, an old, or redundant, perfume spray for instance, or a small gardener's pressure spray, to use for spraying water on to the working paint surfaces to slow down drying while work is in progress.

BRUSHES It is somewhat difficult to advise on brushes for polymers because of the versatility of the medium. In fact you need a fair range. I would advise: one each size 3 and size 7 sable, for work with the medium in delicate form and for fine line work; one each size 6 and size 12 flat poster brush in oxhair and/or sable, for gouache-type work; one size 8 and one size 10 flat nylon brush, for the same purpose; one size 6 and one size 10 round ferrule hog bristle brush, for heavy work with thick impasto; one 1 in. (2.5 cm) good quality house-painter's brush for priming. In addition provide yourself with two palette knives of different lengths and tension; and four cranked painting knives.

N.B. As well as keeping brushes immersed in water during working sessions be sure always to wash them *immediately* after use. Delay of even one or two minutes may render them useless. Just as polymer paints dry exceedingly rapidly, so do brushes.

PALETTES For indoor work in polymer a table palette is best. The mixing area should be white plastic, or glass over a white ground. You can remove dry polymer paint from a highly polished surface with a knife. If the palette is at all absorbent it is literally impossible to remove, by any means, polymer paint which has dried on to the surface. It is a matter of temperament and personality whether you allow old paint to accumulate on the palette or whether you keep it bright and clean after each painting session.

A table easel, height 22 in. (55 cm) width 18 in. (45 cm).

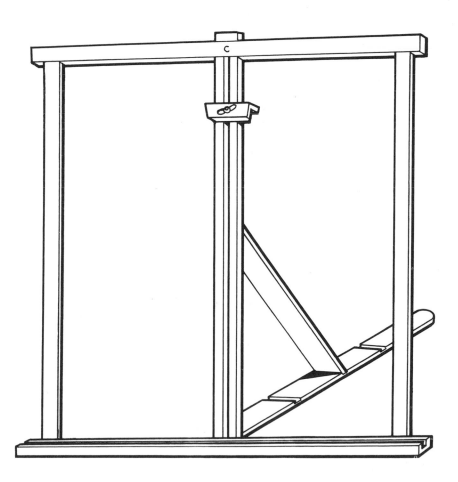

P.P.A.—D

For outdoor palettes refer to page 39 and the box easel. This all-purpose box enables you to carry everything with you, though for polymer exchange the wood palette for a plastic palette of the same size. Artist's colourmen supply white plastic palettes. The old familiar enamel plate is a useful standby palette. It can be soaked in the sink or bath overnight, and the paint can then be removed. In some respects the tear-off paper block palette is a valuable accessory with polymer paint. A flick of the wrist and you have a completely fresh paint mixing surface.

Studies

It takes a lifetime to develop a painting technique. Each new picture should be another step along the road to perfection. The painter absorbs certain processes and they become almost automatic, instinctive. When technique becomes ingrained it is a big step to change to a new technique and a new and different medium. It may be irritating and slow to work with pimples of paint on the palette, or directly on to the canvas, and having constantly to replace tube tops between each stroke of the brush or knife. But the results are so brilliant in colour that one becomes more and more willing to put up with the restrictions, and more prepared to change. I am a *premier coup* painter anyway, so it is not so very difficult for me to change. But any student using polymers for the first time must learn polymers' rules before he starts or he will encounter difficulties.

It is important when beginning with polymers to experiment first with the paint itself and with the media which go with it; and before you actually do start let me give you a reminder. Keep your brushes immersed to above the height of the bristles in water when not actually painting with them.

STUDY ONE: DRYING TEST Squeeze a 1 in. (2.5 cm) worm of colour from a tube on to a practice board. Spread it out with the knife. Check its drying time. Leave a bit of room for another test on the same board.

STUDY TWO: DRYING TEST WITH RETARDER Squeeze out another worm of colour the same size. Allow six drops of retarder to fall on to it. Mix it thoroughly and spread it out. Check its drying time and see how it differs from study one. As a further test use water instead of retarder, spray water on to the paint, using, if you can find one, a perfume spray or a mouth fixative spray.

STUDY THREE: USING NEAT COLOUR Lay out on the palette the tubes of colour you propose to use. Loosen the caps but do not remove

them. Place a small practice board on the easel, and make a very simple painting by squeezing paint directly from the tubes on to the painting surface and using the palette knife, or painting knife, to mix the colours on the picture surface. Replace tube tops immediately you have squeezed out the paint.

STUDY FOUR: MAKING THIN GLAZES Squeeze out a pea of paint on to a hollow palette and dilute it with a mixture of equal parts of gloss medium and water. Thoroughly mix to produce a dilute wash. Lay the wash on a sheet of paper as for watercolour. Allow it to dry. It should now be waterproof. Test it for being proof against water by rubbing gently with a wet cloth. If colour lifts, repeat the study with a slightly larger proportion of gloss medium. Note the transparency of the wash. This can be used as an initial wash, or as a glaze at any stage during the painting process.

STUDY FIVE: TEXTURE PASTE Polymer texture paste is available from all suppliers, in either tubes or squeeze bottles. It enables the painter to build up a heavy crust of paint or impasto. Either add it to the paint to thicken it, or use it neat and colour glaze over the top of the white impasto. Test this interesting medium, or extender as it is called, by building up an area on a practice board. Vary the treatment. Colour one part by mixing it with neat colour, and colour the other parts by glazing or scumbling over the top.

STUDY SIX: MATT MEDIUM Test matt medium by mixing it with polymer colours. On a test board apply a small area of colour neat. Alongside it lay a similar area mixed with matt medium. Compare the surface difference when dry. Dilute some of the medium with water and repeat the process. Again compare the results.

STUDY SEVEN: GLAZE MEDIUM Mix ten parts of glaze medium with one of polymer colour, or proportions to suit your taste. Mix well with a palette knife. The mixture will produce a brilliant finish. Try three or four patches with varying percentage mixes and observe the varied results.

STUDY EIGHT: MIXED MEDIA Try a purely abstract painting consisting of thin glazed areas, heavy impasto, polymer mixed with matt medium, and with glaze medium. Allow these to dry and apply glazes and scumbles. In other words, explore the medium. Watch carefully what happens on the board, or paper, or canvas, and make a mental note of the effects you would like to repeat, and perhaps use as a

permanent part of your future technique. Ask at your dealers for plastic slip-on tops for your polymer tubes. They fit more easily than screw tops which tend to become fixed with hardened paint. The slip-on tops make an airtight seal and are flexible enough to ride over hardened ridges of paint.

STUDY NINE: FLEXIBILITY TEST Paint two or three films of paint of different thicknesses on to a square piece of canvas and, when it is dry, roll it between the finger and thumb and note its flexibility, non-crackability and adhesive power.

Keep a good sized pot of water handy while you are working. Consider in advance which media you propose to use and have these handy too.

The large 72 × 48 in. (180 × 120 cm) landscape, *Farm*, was painted in polymer (see page 101). The method was mixing and applying one colour at a time, using water as the retarder, and mixing the colour on the table palette. Some paint was applied thickly and opaque and some was laid as transparent glazes. It was painted, because of the fast-drying character of the pigments, using a modified oil technique, but taking into account the vital need to prevent the paint in the tubes and on the palette from drying too quickly. The original of the picture is intensely colourful and after seven years remains completely stable.

5 Pastel

Pastel is a comparative newcomer to the artist's repertoire. It began with the pastel portraits of the late seventeenth and eighteenth centuries (see colour illustration, page 128) and has developed through such artists as Degas, Redon, Rouault, to Chagall and Picasso and so to the medium with which we are familiar today. In spite of this distinguished pedigree one meets with comparatively few pastel works in private collections. There is likely to be an original oil or watercolour in many homes, but how often does one see a pastel painting.

The secret of successful artistic practice is to learn the possibilities and limitations of each of the media before embarking on its use. Pastel has a number of seemingly contradictory qualities. It is one of the most fragile of the media and yet a pastel picture if treated with care is one of the most permanent as to colour. Pastel paintings exist which are as bright as they were the day they were painted two hundred years ago. This is because the pigment is not reduced or modified in any way by the medium, because no medium is used to spread the colour, or to attach it to the support. The normal support is paper or card, with occasional canvas. The pastel colour is attached to it by forcefully grinding the pastel granules into the grain of the paper, card, or canvas. As soon as the grain is full the pigment particles collect as dust on the surface. The only use for a medium is as a binder to hold the pigment particles together in the form of sticks.

It is not possible to produce impasto in pastel paintings. Nor is it possible to produce a transparent glaze; though a somewhat similar effect can be achieved by making a loose crosshatching with strokes of a different colour on top of another colour. By this process, the under colour shows through, and a vibrant effect is the result. If the surface becomes clogged spray, with fixative, the part you wish to work again, allow it to dry, and you will then be able to work over the top.

The pastel medium allows dramatic effects but it is not suitable for large scale work. A workable maximum, for the student at any rate, would be 20 × 28 in. (50 × 70 cm).

Being a dry medium an instantaneous effect can be produced. As you place it on the paper so it remains.

It is not easy to mix colours: to produce orange, for example, lay alternate strokes of scarlet and cadmium yellow, and smooth them

together with finger or stub of paper. Too much smoothing, blending, or smudging are practices to be avoided if possible, as it takes the life out of the pigment. It is better to buy a large range of pastels and use a separate pastel for each grade of colour.

Equipment and materials

DRAWING BOARD For indoor work you will need a drawing board, and its first essential is that it should be absolutely smooth. Any small, surface irregularities will show as blemishes on the face of the paper. Any smooth board 30 × 20 in. (70 × 50 cm) will do so long as it is unbending: Formica, hardboard, Masonite, plywood well sandpapered (glass-papered). For permanent use indoors, you should invest in a professional artist's battened drawing board, international size A 1, 23 × 33 in. (59 × 84 cm).

Clip paper to the board with either bulldog clips or drawing-board clips.

EASEL The drawing board is essential and this can be propped up on the work top at a convenient angle, though it is better to use a table easel, see illustration page 77. A box easel (see illustration page 40) is invaluable because once again you can carry everything in it when working out of doors. A box easel is a good investment for any medium.

HOMEMADE PASTELS If you are particularly interested in pastels you must experiment with making your own pastel sticks. Mix a dough comprising pigment in powder form, gum tragacanth, water, and a little alcohol and naphthol as preservative. Roll out the dough into sticks and allow to dry. Break or cut to appropriate lengths. Full details of the procedure can be found in Reed Kay, and Ralph Mayer, see Further Reading page 148. Only non-toxic pigments should be used, because of the danger of inhalation of the dust which is released into the air while working.

INITIAL PALETTE Let us suppose you keep to the principle of trying out the medium first. Buy a small box of, say, one dozen varicoloured pastels and see how you like them. They are sold in two or three degrees of hardness or softness. The best artist's variety are of velvety smoothness. Pastels can be bought singly so you can gradually build up a palette to suit your taste. The same advice holds good for pastel as for all the other media. Play safe and only use the known and tested pigments: rose madder (no alizarin crimson is listed), burnt sienna, cadmium red, cadmium orange, cadmium yellow, yellow ochre, terre verte, French ultramarine, Prussian blue, burnt umber, cool grey,

warm grey, black, and white. Avoid the fancy names. Their chemical composition is problematical. Finally, I suggest you include a sanguine chalk (crayon) and a Conté chalk (crayon) in your box.

PAPERS AND SUPPORTS All suppliers hold stocks of papers suitable for pastel. Some are specially made for pastel work. These are well toothed and produced in various tints. Ingres paper is a favourite in Britain. Cartridge paper (drawing paper) is suitable, but is only made in white or off-white, and it tends to saturate fairly quickly. It can be tinted with watercolour or dilute polymer before starting work. If you can acquire waste, brown, packing paper which has remained un-creased, use that for initial exercises. Use the rough side. Canvas glued flat to stout boards makes an agreeable support, as also does strawboard, and Presdwood. As with the other media it is best to try all alternatives and to make your choice on the basis of experience.

Working procedures

The pastel as well as being a pigment is also a tool. Its physical shape enables the colour to be applied in a variety of ways: by using the tip, the flat end, the long side. Try these methods and any others which occur to you. Try crosshatching yellow and blue and find out what sort of green results when you blend them with finger or paper stump.

Select a series of six different papers and work pastel into the grain of each until saturation is reached. Observe the differing reactions of the pastels to the various papers.

Acquire some kneadable rubber, or putty rubber, and experiment with erasing. Try erasing by scrubbing with a clean stiff hog-bristle brush, round size 8 is a convenient size and shape. Use a mask of stiff paper to isolate the area you wish to erase. Take a small piece of new white bread and compress it into a hard tight ball. That will erase pastel, even if it has been firmly embedded in the grain of the paper.

Vary the tilt of the working surface until the excess pastel dust drifts down the paper. Pin a gutter of paper at the bottom to catch the dust and so avoid mess on the work top (see illustration page 87).

Experiment with a combination of watercolour and pastel; water-colour background with pastel superimposed on the wet wash; and superimposed on the dry wash. Reverse the process and superimpose the wet wash on top of a dry pastel underdrawing.

Run a liberal wash of water all over the paper and work with a dry pastel into it. The pastel runs into the water in a very seductive way. Exciting effects can be obtained in this way though it is not very kind to the pastel sticks. Try the first one or two runs with small stubs of pastel which are no use for normal working.

Various ways of working pastel: (*from left to right*) using the tip; the flat end; the long side; and (*below*) the long side sideways. In the resulting lines (*right*) the grain of the drawing board is revealed in the wide strokes. This indicates the surface of the board is not smooth enough for pastel work.

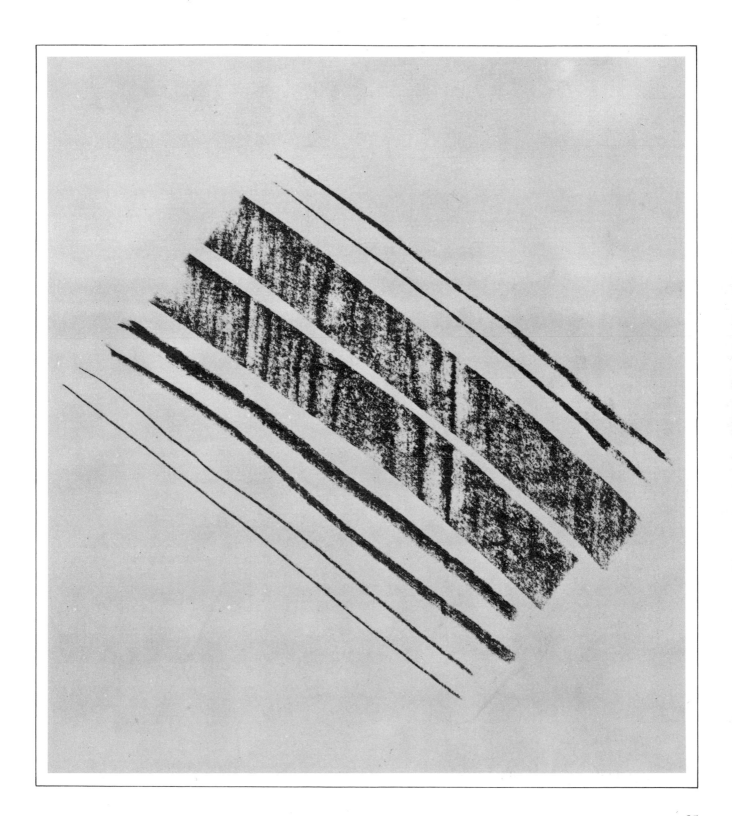

85

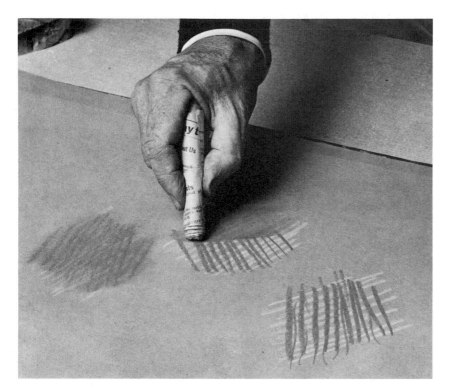

(*left*) The paper stump for blending pastel is made by tearing or cutting a long strip of paper (newspaper is suitable if the print is really dry) and making it into a tight roll. Secure it with a strip of adhesive tape.

(*below*) The bread eraser should be made from new white bread (stale bread crumbles too easily). The moisture in the fresh bread enables it to be compressed and it picks up the pastel particles more readily.

(*right*) A simple but effective device to catch the excess pastel dust. The gutter can be made from stiff paper or thin card. It should be fixed with drawing pins (thumb tacks) to the back of the board.

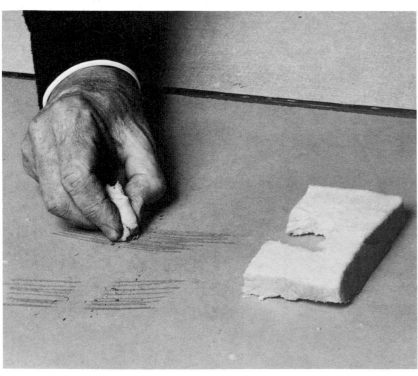

87

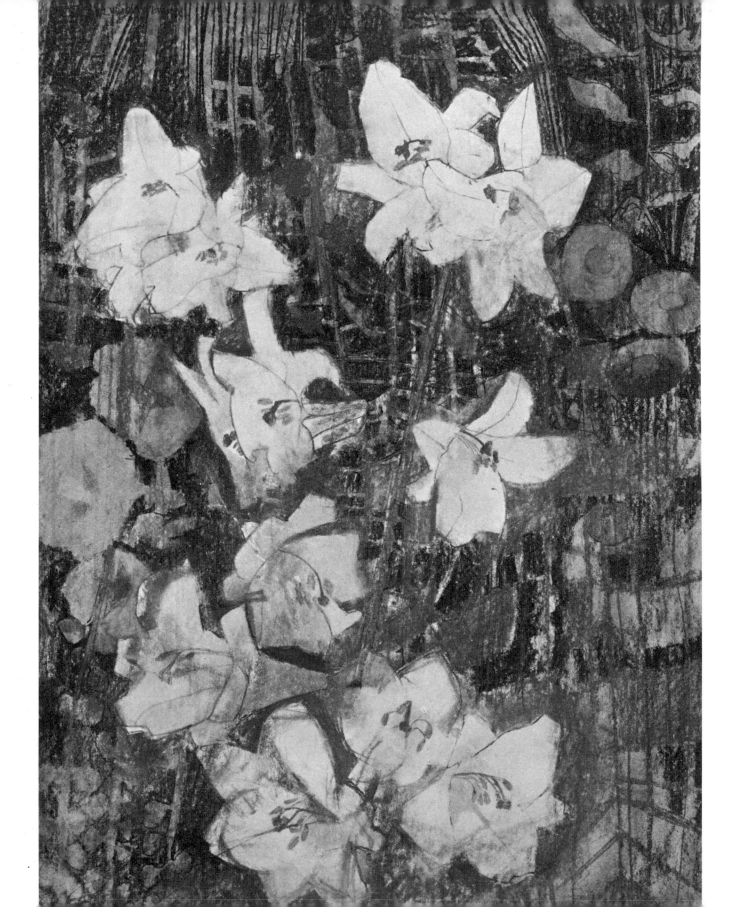

(*left*) *Lilies* by Norma Jameson. Pastel, 30 × 22 in. (75 × 55 cm). Being a dry medium an instantaneous effect can be produced.

The mouth spray in operation. Aerosol sprays are more expensive but they are effective and highly convenient.

FIXING PASTELS Fixing has always been a tricky procedure. Until the arrival of the new fixatives, which are solutions of resins in fast drying solvents, many artists were chary of risking the colour and definition of their work. The new aerosol fixatives are colourless and will hold a pastel adequately. They can be relied upon. At the same time if you wish to explore the older methods try a mouth spray and some sugar water. Try it on a piece of work which is of no importance. Spray one test in the vertical position, another laid flat. The former may run, the second may form pools. You may find you will have to make several attempts. In particular you will need to vary the concentration of sugar. Try white shellac thinned in alcohol with the same sort of spray.

BACKING, MOUNTING (MATTING) When the pastel is finished it is generally on a fairly flimsy piece of paper which, because of the wetting

and the drying, may be far from immaculate. It is necessary, therefore, to make it neat and tidy, so that it may take its place in its ultimate setting, with elegance. It is, in other words, necessary to 'present' it. There are three stages to the process. The first is backing, the second is mounting (matting) and the third is framing.

To back a pastel first practise on paintings which are expendable. Use a water wallpaper paste and mix a generous quantity. Alternatively use a simple flour paste mixed with really hot water.

Use a good quality white board. Strawboard is too absorbent. Cut the board so that it is at least $1\frac{1}{2}$ in. (4 cm) wider all round than the painting which is to be pasted to it. Keep handy two 2 in. (5 cm) house-painter's brushes, one for water, one for paste. Work on a large flat table. Place a large sheet of newspaper on the table. Place the pastel face down on the newspaper. Moisten the back of the pastel with water, but do not overdo it. Paste the sheet of card which you have cut ready. Pick up the damped pastel painting and lower it down on to the pasted card. Cover the pastel with another sheet of clean newspaper. With a pad of soft cloth, work outwards, with gentle pressure, from the centre, to remove air bubbles and creases. Check from time to time. When all is flat and neat, dispose of the newspaper and wipe the margin clean. Place the backed pastel face down and damp the back of the card. This will equalize the tensions on both faces as it dries and will minimize buckling. Place a heavy board on top, or other board weighted with heavy books to give extra pressure.

If you use a good fixative and the backing system detailed above, your pastel is now safe. Bevelled mounts (matts) to put over the front of the pastel, and framing, are best done by a specialist, but some hints for homemade versions are given on pages 106–7.

Oil pastels

An entirely new range of pastels has come on to the market within the last few years. They differ from the traditional variety in the nature of the binder. Instead of the usual gum they are bound with oil. The use of oil as a binder produces several fundamental differences. No dust is produced while working. There is no danger of inhaling toxic pigment dust. It is not necessary to fix them. The colour effect is very luminous. The purists are not enthusiastic about oil pastels but this new medium should not be dismissed out of hand. At least try oil pastels and then decide whether they produce a satisfactory effect. They lend themselves to sgraffito working, i.e. scratching through the oil film with a sharp point to reveal the colour of the paper beneath. Also, interesting blending effects can be produced with brush and turpentine worked over the surface.

6 Encaustic wax painting

Encaustic is a method of painting in which powder pigments are combined with hot melted wax (refined beeswax) and a small proportion of varnish or linseed oil. The colours are mixed with a palette knife on a heated palette and are then applied to the support with brush or palette knife. They can be applied thinly or as a heavy impasto. At the end of the painting the colours have to be 'burnt in' (hence the term encaustic) by passing a heat source over the surface, i.e. a small electric bowl fire, or heat lamp in a bowl reflector.

Pigments dispersed in wax become completely permanent when the wax has set cold. Egyptian mummy portraits executed in encaustic wax (see illustration, page 102) are still to be seen in virtually perfect condition. The paint/wax combination does not darken or yellow with age. It is moisture resistant. It allows flexibility of working and so, from being a somewhat lost art after tempera and oil became popular during the Renaissance due to their versatility, encaustic wax has won a new place in the modern painter's repertoire.

Equipment
This is modest and comprises hog bristle brushes, palette knives, and an encaustic palette. The palette is the main item. In the initial stages it can be improvised with two house bricks and a commercial metal powder-colour palette. If you use an improvised palette of this kind

Improvise an encaustic palette using two house bricks, a metal palette or a baking tin of similar design, plus a domestic candle stub, all arranged on a fireproof mat.

A more sophisticated encaustic palette can be set up using a domestic two-ring hot plate (A) with a heat control for each ring. The mixing surface is a shallow steel box (B) which should be bolted to the hot plate (C).

A

B

C

you may find it better to use a brush for mixing. Stand the bricks on an asbestos mat. Use a nightlight or a stub of candle, and move it around under the palette wells, melting and mixing the contents of each well as required. Waste stubs of children's wax crayons can be melted down in such a palette and can be used to get the feel of wax. If you decide you like the medium and wish to develop it, the more sophisticated palette illustrated can be acquired or made.

In the past encaustic palettes were heated with glowing charcoal. This must have been cumbersome and dangerous. Modern controllable electric apparatus makes the encaustic process much easier and probably accounts for the resurgence in popularity of the medium.

Unless the support is rigid the painting will be at risk through cracking of the wax. Wood, hardboard (Presdwood) or any other firm ground should be used. This can include metal, building boards of various kinds. If a ground is needed, to prepare any of the supports, glue gesso should be used. Glue gesso is made by mixing together a white pigment such as whitening, Paris white, or gilder's white, with a tenth by volume of zinc white or titanium white. These should be mixed with water-soluble glue. The whitening and zinc or titanium constitute the 'filler'. The proportions should be approximately 1 quart (1.4 litres) glue water to 3 lb (1.4 kg) of filler. The glue water should be made with 1 quart (1.4 litres) of water to 2 or 3 oz (56 to 85 g) of glue crystals.

Working procedures
There are two main methods of encaustic painting:
1 Painting on a warmed support. By this method the support is heated from the back with a heat lamp; hot wax is painted on to the hot surface; and wet in wet procedure can be adopted. When the heat source is turned off the support cools and the wax sets.
2 Painting on an unwarmed support. If this alternative is chosen you will find the paint hardens as soon as it touches the cold surface. Corrections can be made by heating the surface of the painting with a heat lamp and then by removing the offending passage with a palette knife.

The need to clean the palette after each painting session does not apply to encaustic. Let it cool and harden. Then you can warm it up and start work again straight away next time.

BURNING IN Place the painting flat on the work table and face up. A heating lamp, or coil element in a bowl reflector, should then be moved slowly, at about 6 in. (15 cm) from the surface of the paint, backwards and forwards, and up and down, until the whole surface is melted together, each paint stroke to its neighbour and the whole paint film

to the ground. Avoid too much heat or you will fry it, and the impasto and the brushwork will lose definition. The colours may bubble or run and this would be disastrous. Heavy and lightweight pigments behave idiosyncratically under the burning-in process. Learn to watch and manipulate and to make use of accidental effects.

When the picture has been burnt in and is cold again, the surface can be polished with a soft rag. This will produce a rich silky sheen which is very attractive, and peculiar to this medium.

Map by Jasper Johns (b. 1930). Encaustic collage, 60 × 93 in. (152 × 236 cm). Jasper Johns has used the encaustic technique to build up a lively surface texture.

7 Tempera

There are a number of different tempera techniques:
1 Egg-yolk tempera.
2 Tempera using emulsions of egg yolk, egg white and oil.
3 Tempera using glue or gum instead of egg (not so reliable).
4 Polymer tempera paint based on emulsions of synthetic resins (see page 72).

The common factor in all of these is that the pigments are dispersed in water-based emulsions which, when painted on to a panel, allow the water to evaporate and leave the paint granules behind, locked up in a skin which is moisture resistant and can be made waterproof. Tempera paints dry rapidly and so are useful for making underpaintings for oils. Tempera underpaintings save time.

Some manufacturers still supply ready prepared egg-tempera colours, especially in Germany where the medium is popular. But there is a simple recipe for egg-yolk tempera which can be tried as a first experiment. You will need a glass or china palette, a palette knife, one fresh raw hen's egg, water, artist's grade powder pigments, avoiding toxic flake white, Naples yellow, chrome, cobalt and emerald green because of the danger of inhalation. Grind the pigments, one at a time, with water and a palette knife, to a stiff paste. If made in quantity the paste can be stored in screw-top jars where it will keep indefinitely. Retain some of the paste on the palette for mixing. Carefully separate the egg yolk from the white. *All* the white must be removed. Having separated the yolk roll it about on a sheet of clean blotting paper to remove the last traces of white. Carefully lift the yolk and hold it over a small glass container. Pierce the skin of the yolk and run the contents of the sac into the glass container. Discard the yolk sac. Add half a small teaspoonful of water to the yolk and stir. This simple mixture is the binder for your tempera paint. Apply a few drops of it to the paint waiting on the palette and thoroughly mix it with the palette knife. Your tempera paint is now ready for use.

Working procedures
Egg tempera should be carried out on a rigid support. The best type is a wood panel, Presdwood, or hardboard. Whichever you choose it should be given a surface of gesso. Premixed gesso can be bought as a

(*overleaf*) *Welders*, 1943, by Ben Shahn (b. 1898). Tempera, 22 × 39¾ in. (55 × 101cm). A remarkably powerful composition achieved with great economy of means in a fragile medium.

dry powder, or as a liquid, or it can be made in the studio. The recipe is as for use with encaustic painting (see page 93).

Sandpaper (glasspaper) the panel first and dust off. Size the panel front and back; if you only size *one* side the panel will warp. Recipe for size: 1½ to 2 oz (42 to 56 g) glue crystals to 1 quart (1.4 litres) of water. Let the panel dry for at least twenty-four hours. Apply a dabbed or stippled first coat of gesso, to provide purchase, to both sides of the panel. As soon as it is dry apply a second coat on each side, brushing out more smoothly. Repeat the process until you have five coats at least. Each succeeding coat should be brushed on at right angles to the previous one to help keep the surface level. When you have a sufficient build up of gesso allow it to dry absolutely. Sand off with fine sandpaper (glasspaper) and remove all powdered gesso by dusting with a cloth. It should now be smooth and cool to the touch.

True egg tempera at its best should be applied thinly with good quality sable brushes, both fine pointed and blunt ended. Thin the colour on the palette with water. Do not overload the brush. Rather use it almost dry and apply to the smooth gesso surface in the style of a crosshatching. Allow the underpainting ten minutes to dry hard. Then proceed to a second crosshatching and so proceed to build up the painting little by little. The effect of the superimpositions will be one of translucent subdued brilliance. Allow the painting to dry in strong daylight. The surface can be polished with a silk cloth to give extra brilliance. A fine tempera painting by Ben Shahn is illustrated on pages 96–7.

8 Fresco

Fresco has had an incalculable effect upon civilization. It flourished from the late thirteenth to the mid-sixteenth centuries in Italy and elsewhere. In many ways it was the equivalent of today's mass media. It was the vehicle of communication, to the masses, of mythology, religion, philosophy, politics.

Working procedures

An intricate, cumbersome, and complicated procedure, fresco consisted, still consists today, of constructing a porous wall with the interstices between the bricks cut back so as to hold four layers of mortar or plaster. The ingredients of the mortar are lime and aggregate.

The lime – caustic lime, quick lime or hot lime – may be obtained from builder's merchants in powder form. Prepare it as follows. Mix it with water in a wooden trough. Use a long-handled mixer. Avoid splashes or you will be burned. Caustic lime plus water produces slaked lime. Mix the slaked lime to a fairly fluid consistency. Let it lie for at least a week. As it ages it thickens and becomes what is then known as 'lime putty'. Water is added to the lime putty plus aggregate to make the various layers of mortar. N.B. Do not add water until you are ready to start applying the mortar.

The first layer of mortar, called the 'rough cast', is a mixture of one part lime and three parts aggregate (coarse sand or crushed brick). This provides a 'tooth' or grip for the next layer. The second layer, known as the 'brown coat', is finer in texture and is one part lime and two and a half parts coarse sand or pulverized marble. The third layer is called the 'sand finish' and is composed of one part lime and two parts finer sand or marble dust. The fourth and top coat, or *intonaco*, comprises one part lime and one part fine sand or marble dust. Each successive layer is finer in texture than its predecessor and each must be kept wet as the work proceeds and when laying the *intonaco*.

The total depth of mortar covering the brick may be as much as 2 or 3 in. (5 to 8 cm). The smooth top coat, the *intonaco*, upon which the painting is laid should be about $\frac{1}{8}$ in. (3 mm) thick. The painting must be carried out while the surface is still wet. The top coat should only be spread as far as the next work session can deal with. Painting

must be completed within its drying time and before the lime crust forms. Make a full size preliminary drawing and trace it on to the surface of the *intonaco* to guide you when working. Keep a sponge and a 1 in. (2.5 cm) house-painter's brush handy to wet the surface from time to time.

The pigments must be mixed or ground in water and thinly applied to the *intonaco*, using softer, longer bristled brushes than those used for oil. The pigment penetrates into and below the surface and, as it

Farm by Norma Jameson. Polymer, 72 × 48 in. (180 × 120 cm). Because of the fast-drying character of the pigments a modified oil technique was used: mixing and applying one colour at a time, using water as the retarder, and mixing the colour on the table palette.

(*left*) Construct a practice panel for fresco by making, or commissioning a joiner to make, a suitable sized frame, say, 24 × 36 in. (60 × 90 cm). The woodwork must be strong enough to hold the various layers of mortar.

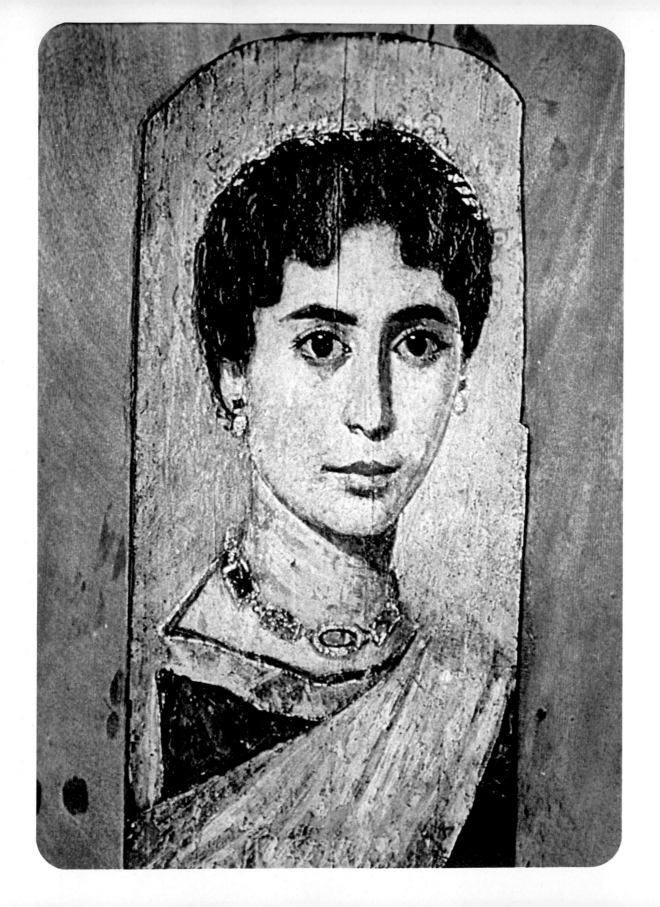

Portrait of a Lady from the Fayum, Egypt (fourth century AD). Encaustic wax, 17¾ × 7¾ in. (45 × 19.6 cm).

(*right*) *A Group of Poor Clares*, a fragment from a large wall-painting, by Ambrogio Lorenzetti (active 1319–47). Fresco, irregular shape, 23 × 20½ in. (58.4 × 52 cm).

dries, it is locked in permanently. In fact it becomes part of the architecture. In present day terms this would pose problems, so most modern fresco artists avoid this disadvantage by making a wood frame with a supporting device at the back and then laying the mortar ground, in block form, within the frame. When it is painted, dry and hardened, it can then be placed into the wall.

Construct a practice panel by making, or commissioning a joiner to make, a suitable sized frame, say, 24 × 36 in. (60 × 90 cm) using 2½ × 2 in. (6 × 5 cm) wood. Screw wooden or metal laths across the

103

back. Drive 2 in. (5 cm) screws into the inside of the frame, as illustrated, leaving 1 in. (2.5 cm) of the screw standing proud to act as a locking device, to hold the mortar panel when it is in place. Lay the frame on a sheet of hardboard while you are filling in the layers of mortar. Build up the mortar so that the *intonaco* is flush with the front edge of the wood frame.

The pigments which may be used for fresco must be compatible with, or rather unaffected by, the alkalinity of the lime in the mortar. A safe standard palette would be: ivory black, cadmium yellow, raw sienna, yellow ochre, cadmium red, Indian red (or any of the earth reds), Mars red, cerulean blue, ultramarine, terre verte, viridian, Mars violet, burnt sienna, burnt umber, raw umber, and titanium white.

The colours change somewhat as the mortar dries and considerable experience is necessary to prejudge how they will look when dry. The main factor to remember is that the whole procedure must be carried out with the mortar in a damp condition and within the drying time of the top layer, and the intervening layers must be damped at each stage.

An advantage of fresco surfaces is that they are non-glossy and so they do not have bothersome reflections which sometimes make oil paintings so difficult to see properly.

Fresco is the most different of all the painting techniques we have discussed so far. It would require a whole book to itself to deal with fully. Any reader who wishes to pursue the subject in depth would do well to seek out a fresco painter and offer to work as his/her assistant for a time, as an apprentice, in the style of the Italian *bottega* system.

9 Framing and presentation

Framing and presentation are more a matter of long experience, experimentation, and the exercising of discrimination and sensitivity than anything else. Framing is important. Mention has already been made of it on pages 30 and 89–90 in the special cases of watercolours and pastels. Do not spoil a good picture with a bad frame. You will have to go by trial and error at first. With experience you will achieve success.

Styles in framing have changed a great deal in the last ten to fifteen years, due to the availability of a much wider range of materials. Blockboard, chipboard, and perspex (Plexiglas) are some of the most widely used new additions.

There are a few simple rules for framing which will help the painter to make a right decision about the way to present, enclose, or surround his work whether in heavy frame, light frame, edgeless frame, or no frame.

Rule one 'Any old frame' is not good enough. The impact of any painting can be ruined by an inappropriate frame.

Rule two If in doubt let 'simplicity' rule your judgment.

Contrasting styles of framing (*from left to right*) blockboard and perspex frame, traditional oil and watercolour frames.

Rule three The frame should not swamp the picture. Neither should it look too flimsy. It should serve gently but firmly to separate the picture from its background while at the same time relating it with the surroundings. This is not always an easy task.

Rule four The frame and the site in which it is going to hang must be compatible.

Take, for example, a piece of blockboard 42 × 32 in. (105 × 80 cm) and a piece of perspex (Plexiglas) of the same size. Paint the board white all over, edges as well. Carefully drill at least six holes in the perspex; take care, it is brittle. Lay a watercolour, or print, or pastel, or other work of appropriate size on the white surface. Secure it by sticking the corners and middles of the sides with clear plastic adhesive. Fix the perspex with screws, as illustrated. You now have a clean neat enclosure. But how would this look if it were hung alongside heavy gold frames in a Victorian interior? It would be incompatible. Yet the same mode of presentation of the work, in a modern gallery, would probably be absolutely at home. So one must seek for compatibility between picture, mode of presentation, and the character of the interior in which it will hang.

There are certain traditional modes of framing. Oils should have substantial frames related to picture and interior. In most exhibitions, or up to date interiors, a simple strip, lath or 'bagette' frame is acceptable and often very successful.

Watercolours, etchings, prints should have a cut mount, white or off-white, with perhaps wash lines and a narrow frame, say, $\frac{3}{8}$ or $\frac{1}{2}$ in. wide (1 or 1.5 cm) and $\frac{1}{2}$ in. (1.5 cm) deep, in polished black, or gold, or limed wood, or plain wood. Watercolours also look good in the blockboard and perspex style outlined above. Delicate work such as watercolour needs gentle treatment. In my view a white surround is essential, to provide a silence in which the work can exist. Framed up close this kind of work seems cramped, and diminished.

Gouache, depending upon the tone range, the nature of the subject, and the treatment of the medium, can be framed either as oils, or as watercolour.

Polymers will mostly need the same framing treatment as oils.

Fresco will need to be presented on a piece of 'simulated wall' made into tablet form by the use of a stout wood frame and strong backing (see page 100).

Most artist's manufacturers make kits of frame parts, ready mitred side pieces and wedges for the corners. They are very much cheaper than specially made one-off frames from the frame maker.

Most professional framers are prepared to discuss problems and to give advice.

(*top*) Bagette or lath frame and (*below*) a modern watercolour frame.

107

10 The painter's vision

The painter's ability to manipulate his chosen medium, coupled with his predilection for one particular element or elements of art, plus his personally selected subject matter, combine together to make the artist's style or, in the hackneyed phrase, 'The Painter's Vision'. Compare the work of El Greco, Bernard Buffet, and Paul Cézanne. Sometimes this same predilection will also govern the artist's mode of dress, the type of interior in which he lives, the way he designs his garden, if he has one. Look at and compare the paintings by Matthew Smith (page 52), the Douanier Rousseau, Bernard Buffet, and Piet Mondrian.

Decide which sensitivity was at work during the making of each of these paintings. Decide which one pleases *you* most and which element it is that gives you the most pleasure. The point of this thinking is to stimulate within the reader an awareness of his own responses. Constable reacted to the English countryside, Ben Nicholson responded to cool intellectual geometry.

Subject matter

Finding painting subjects is virtually looking for openings and opportunities provided, by nature and the environment, to celebrate the painter's love of colour or line or pattern or texture or shape or form. It might be said that the subject chooses the artist.

Sensitivity is a 'trigger mechanism'. The more you train your sensitivities the more you will see and experience. The more you experience, the more opportunities you will find in the environment which will present themselves as possible subject matter. One way of working and studying is to decide your own sensitivity and then positively and deliberately to look for subjects which will enable you to demonstrate and *use* your special sensitivity. A beginning could be made by testing your reaction to colour in the abstract.

The portrait painter in particular, and in fact any artist who accepts a commission, may well be put under pressure because of the artist's difficulty in reconciling his own aesthetic conscience and the requirements of the client. The hullaballoo over Augustus John's portrait of Lord Leverhulme was a case in point. Who calls the tune, the piper or the people who pay him?

(*above*) *Self Portrait* by Bernard Buffet (b. 1928). Oil, $57\frac{5}{8} \times 44\frac{7}{8}$ in. (146.3 × 114 cm). Buffet's style can be recognized immediately by its linear character.

(*opposite above*) *The Snake Charmer* by Henri Rousseau, the Douanier (1844–1910). Oil, $65 \times 73\frac{1}{4}$ in. (165 × 186 cm). Rousseau was vitally interested in the basic form, structure and pattern of nature.

(*opposite below*) *Composition in Grey, Red, Yellow and Blue* by Piet Mondrian (1872–1944). Oil, $28\frac{3}{8} \times 27\frac{1}{4}$ in. (72 × 69.2 cm). Mondrian's work is characterized by his feeling for formal relationships between geometrical shapes of colour.

Do not bother too much about whether the picture will *sell*. Decide your own goal and go straight for it. Bother much more about developing your skills and keeping to your own aesthetic preferences. You will be in good company. Think of Rembrandt. He displeased his contemporaries but left behind him a legacy of some of the finest works of art the world has ever seen.

Motivation

Why do you feel the urge to paint? Untold numbers of people feel a strong compulsion to take up the brush. More and more are doing so and you are one of them. The only way to find the answers to this question is to look within yourself and try to uncover your motives. Readers' motives will be as various as the number of different individuals concerned.

The French Impressionists were motivated by fascination with the science of light. *Guernica* grew out of Picasso's bitter experience of the civil war in his homeland, Spain. The young gentlemen of the seventeenth and eighteenth centuries made watercolour records of their Grand Tours of Europe. Mary Moser loved flowers. She was motivated to preserve their few moments of fragile beauty. You may be started off by entering a painting competition, and a simple desire to compete. A desire to make something may trigger you. Your motivation could be a suppressed desire, a romantic dream of living the life of a Bohemian, or a desire to make money, to be famous. Any motive, worthy or unworthy, can start a student along a path of life which may lead who knows where. Perhaps where some least expected, and to their surprise.

Some may be drawn to explore by the simple device of merely mixing paint, or by dabbling with paint for the pleasure of feeling the texture, and watching the colour changes in the fusion of pigments on the palette. Others may begin with simple curiosity, as I did with budding roses. 'It is something slightly mysterious. I wonder whether I could do it?'

Whether the motivation is logical or illogical, obvious or subtle, there is little doubt that the most powerful motivator is experience. Not just experience in the broad context, but a sharp concentrated visual or emotional experience; sunlight on turbulent water, a blaze of summer flowers, the vitality of a human body, an expression in a human face, a mathematical concept, a musical parallel, a silver flute melody over a rich brown orchestral harmony.

We should draw a distinction between motivation, stimulus, and inspiration. Motivation is a general influence. Stimulus is more immediate and intimate. Inspiration is more like a blinding revelation arising out of contemplation of a specific circumstance, concept, or object, animate or inanimate.

Study

Motivation by itself is not enough. We may be highly motivated and yet produce little or no work because we lack sufficient application. In other words we are too lazy. Motivation must be supported by positive energy. One source of energy is constant study, the specific practical kind, studies in each of the media.

Every painter is a student painter. Turner remained a student all his professional life. There is no real dividing line between the amateur, the professional, and the student, or, if there is a difference then it is in attitude more than anything else.

The most appropriate medium depends upon the student's tastes and sensitivities. If he has a first interest in colour and textures then

painting is an appropriate medium for exploiting this. A prime interest in line would be best encouraged by the medium of drawing, or by linear techniques in painting. An interest in pattern would perhaps lend itself to painting and to one or other of the design media – batik, embroidery, appliqué, collage, screen printing, or mural design. These media are complementary to painting in that they call for the exploitation of the same sensitivities on the part of the artist. It therefore follows that if you try your hand at, say, paper collage this may very well develop your sense of pattern. If it does, then this could add to your technique when you return to painting. The same goes for the other media. Appliqué may help to develop your sense of texture. Mosaic could help your sense of design. If any of these complementary media attract you, make a practical study of them. You will find it a form of study which will ultimately enrich your painting.

Walk through an art gallery. Look at the pictures selectively. Do not try to look at them all. Go straight to one you like. Analyse why you like it, if you can. If you cannot, leave it for a while. Then go back and try again. If you succeed in analysing your response you will learn a bit more about your own sensitivities.

Read every press art criticism you can lay your hands on. Then go and look at the related exhibition. Compare your reaction with

Coin and Musical Instruments by Ben Nicholson (b. 1894). Oil, 42 × 48 in. (100 × 120 cm). Lyrical white lines imposed on a background of warm greys and browns. The effect of this elegant painting is the visual equivalent of a solo melody against a rich orchestral background.

111

what the critic writes. Keep an open mind. You will find out a lot about critics and a lot about their modes of literary expression. At the same time you will sharpen your own critical faculties.

If you have practical problems in a certain painting area, it helps to choose one of the masters and to see how he solved the same problem. I remember how looking at Christopher Wood's works of the 1930s helped me with problems in colour. He has remained a 'companion' ever since, his effect upon me was so great.

If you have a pianist friend, especially one with an interest in Chopin's études, talk to him about them. Ask him, or her, what he thinks is the function of Chopin's or Czerny's studies. Then translate his answers into painter's terms. In conjunction with this, study a copy of Leonardo's notebooks and sketchbooks.

It is possible gradually to build up a body of knowledge and experience, a crumb here, a phrase there, a hint from an overheard conversation, a sentence in an art journal, a bit of advice from a knowledgeable friend or instructor. Visit every kind of exhibition which comes your way. Look through and read every art book you encounter, not just those you like the look of but *every* one, even those which contain works you positively dislike. The text may provide a sentence, which contains a germ which will draw into a meaningful whole a group of disconnected threads which are milling around in your mind.

Movements in art have mostly been born out of associations of like minds; the Euston Road Group, Picasso and his associates centred on Paris, Gauguin and his breakaway group in Pont Aven, Brittany, the Bauhaus, the Pre-Raphaelite Brotherhood. Become a member of a group, however modest. Talk to your painter friends.

Many educational organizations run art classes. The standard of the teaching, equipment and accommodation varies. Join one and try it for a time. If you cannot find what you need leave and try elsewhere. Some artists give private lessons in their own studios. This could be a productive way of studying.

Herbert Read's *The Meaning of Art* is a book which deals with practical, historical, and philosophical aspects, but which is divided into short paragraphs, each of which can be considered and thought about as a separate entity in any spare moment during the day. As well as books on art, there are a number of journals which specialize in art. Some are designed to provide practical help for the student and the trained artist. Others deal more generally with the subject. Examples are quoted on page 149.

One of the most important aspects of study for the student painter is the regular use of a sketchbook. Carry a small one in your pocket or handbag. Make sketches and notes about anything which attracts your

attention, which amuses you, or which you think may come in useful as material for later work. Keep a larger sketchbook in your painting kit or in the automobile. Never miss a chance.

Date each entry in the sketchbook. Make a compact with yourself to do some work in it each day. After a year look back. Compare past work with present. Compute the differences. A little drawing in your sketchbook each day will guarantee improvement.

The camera is also an invaluable aid. It is efficient for quick notation, but beware of its dangers. It can ensnare you by tying you too close to reality. It can tie you to imitative, representational painting so that it restricts your own natural mode of creativity.

Drawing for painting

Preliminary drawings for painting, if you really *need* them, should be indications of the composition; of tones, masses, textures and boundaries. Their main use is to fix the arrangement of the painting and the layout of the various areas, directions of line, the linear rhythms, and the balance of areas of colour.

Drawing is a part of the painting process. The laying of one area of paint beside another in a precise way entails the 'mapping' of the areas, of plotting defined limits. Some artists actually use line to do this. To others mental planning is enough. No line need go down on the paper, or canvas; the paint areas are placed as visualized. The second process is more exactly painting. The margin between drawing and painting is marginal! You can paint with a pencil, you can draw with a brush.

One frequently hears art school students say, 'Drawing is a thing of the past.' What would Leonardo have said about the vast areas of art-school flat colour abstracts? Perhaps he would have joined the students in making them. Both he and they have one thing in common. They are all innovators. Though on one point he would have differed. He would never have agreed with them on drawing. He was a master draftsman. There is a considerable difference between 'drawing as drawing' and 'drawing in preparation for painting'. A typical working drawing for oil painting is illustrated.

Working methods

The inexperienced artist sometimes tends to get over anxious about his paintings. He knows his technique is insufficient for his needs. The number of paintings which he considers, in the early days, to be successful, or partially successful, may be at the most one in twenty, and so he tends to become neurotic about them. The result is his products become timid and tight. I advise you to vary your approach.

Working drawing for an oil of Ile St Louis, Paris. Detail is avoided. The sketch is a shorthand note of the proposed composition.

La *Maison à l'Auvent* by Maurice de Vlaminck (1876–1958). Oil, 32 × 28 in. (80 × 70 cm). Vlaminck was famous for his intense, even violent, style of painting. He literally attacked his canvases. Look at examples of his work and experience for yourself the sense of turbulence which emanates from his pictures.

Occasionally go into the attack telling yourself 'you *can* do it'. It is not the end of the world if one more painting fails. A bold approach will do your ego a lot of good. Another word of advice; use the palette knife from time to time. You cannot be niggly with that. Did you ever see a feeble painting by Vlaminck?

Do not be downhearted if you fail at the first attempt, stick at it. It will come right in the end. There is plenty of evidence to show that the great masters were not infallible, they often abandoned their first attempts and started again.

Not all readers will be able to devote all, or even most of, their time

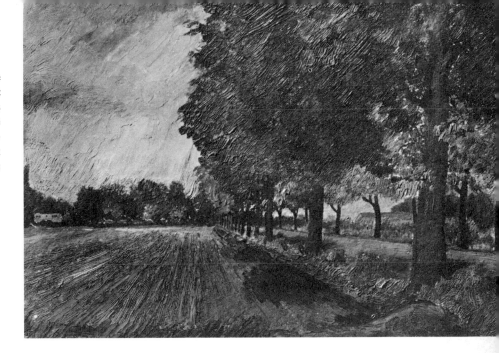

A small wooden oil paint box. The palette fits into the lower part of the box where it rests on the partitions. When the box is closed, the palette is kept in place by the ribs in the lid. The lid, in the open position, serves as an easel. A portable box was used to paint the small oil, *Le Chemin à Courtrai*, Ghent 1945 (*right*).

to painting, but, however much you can spare your aim should be continuousness of working, i.e. some, if only a short period, *every* day.

It is possible to keep painting going even in a crowded itinerary by keeping handy a small, homemade, wooden oil paint box which holds a basic set of oil colours, a dipper, a small cloth, a small bottle of medium and three or four brushes. The handles of the brushes may need to be slightly shortened before they will fit. The box could be, say, 10×8 in. $(25 \times 20$ cm) with a slot in the hinged lid in which a wet painting board can be carried safely. A painting done by a student who carried such a box all through the Second World War is illustrated.

If your life is excessively full you will have to devise special ways of making painting time available. Try setting up a permanent still life of, say, dried grasses, seed heads, thistles, artichokes (French variety), hogweed, cow parsley, and others. Import a table palette and an easel. In spring, summer and autumn there is early light and you can paint for an hour before breakfast each day. Slowly the picture will mature. The subject must be a stable and unfadeable one, because under these conditions a 48×24 in. $(120 \times 60$ cm) painting might take as long as six months to complete. You will be confronted by the work every day. You will be in contact with the work all the time.

Cézanne used artificial flowers. He too was a slow worker. Many painters use aids of various kinds, twigs, small shaped stones, sand or fine soil to construct indoor landscapes. Tintoretto modelled human figures out of clay and then suspended them inside a modelled clay box with windows. By this method he achieved extreme poses of, for instance, flying angels. He arranged lighting so that the form of the

A landscape built in the studio. The large tree is a piece of driftwood. The slender trees are prunings from a plum tree. The very small tree in the distance is an inverted plant root. The bushes are made from a dried hydrangea head and some heather. Sand, soil and some pebbles make the foreground and middle distance. The 'back drop' is a white card with a wash of grey gouache to resemble distant mountains and clouds.

models could be sharply defined and dramatically lit. There are good precedents for using all sorts of painting aids.

Those artists who have made considerable contributions to painting are recognizable by, amongst other characteristics, their distinctive brushwork. Van Gogh used heavy impasto achieved by the use of snake-like strokes. Rembrandt used heavy, crusty, sombre coloured impasto. Cézanne frequently built up pearly enamel-like surfaces of paint by superimposing a series of thin glazes one on top of another. Toulouse-Lautrec, as mentioned earlier, regularly used pigment thinned with turpentine on absorbent strawboard. These different methods are part of what produces, as it were, the handwriting of the painter, and part of what makes the finished work immediately, visually identifiable. One factor however is common to them all. These painters give exactly the same importance, in terms of paint surface, to every square inch of the picture. In every square inch of the canvas or board the paint is laid in exactly the same sensitive way as every other square inch. In that way the painter will produce a work with a unified surface. Look at Modigliani's *Seated Nude* and the diagram. The shapes are simple, especially the face. If it were drawn in too much detail it would attract too much attention. The spaces A, B, C, and D are painted with great sensitivity in small flakes or scales of subtly varying colour related to the rest of the picture. They are delicately laid and the brushwork is

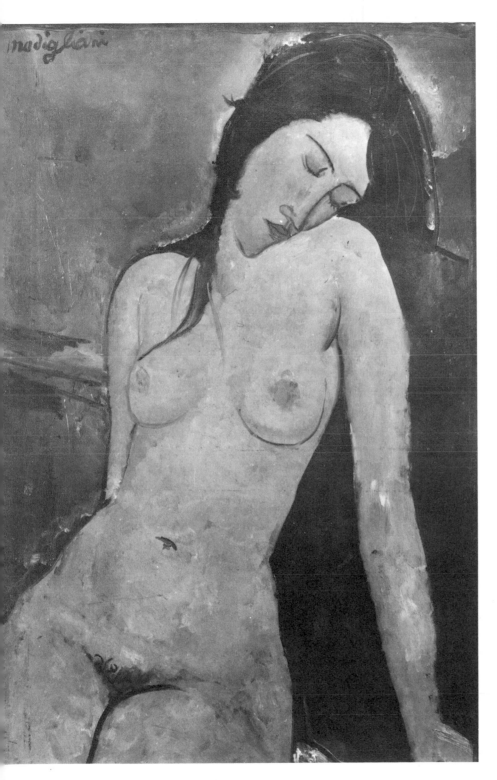

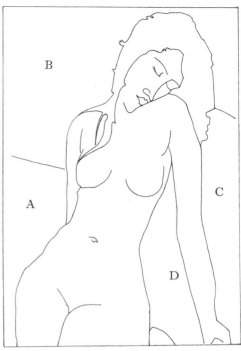

Seated Nude by Amadeo Modigliani (1884–
1920). Oil, $36\frac{1}{4} \times 23\frac{1}{2}$ in. (92×59.7 cm).

varied in direction and impasto. The result is jewel like. In Modigliani's paintings the charm of the work lies every bit as much in the paint surface as it does in the subject matter. The important point being that the whole of the canvas is treated as being of equal importance, no one part is more or less important than the rest. Above all in your own work pay special attention to the paint surface. Avoid laying the paint in the way a housepainter does. The direction of the brush stroke is vital. The best solution is to lay the paint so that no one direction is apparent. Check these assertions and this advice by visiting art galleries. Observe how other artists deal with the problem.

It pays to go through your old paintings from time to time. You may find one which is good as far as it went when first painted. It may have been stored away for some considerable time. At the time you painted it you felt it was nearly good but could not decide what made it somewhat less than satisfactory. Now with the greater experience you have gained, you can see at a glance. Finish it and you will have another work available for sale or exhibition, or both! One of these rescued works is reproduced here, together with the final version. There was a gap of seven years between the two versions.

White Flowers. Oil, 24 × 30 in. (60 × 75 cm). Compare the two versions. The second has been added to in various places where the original appeared to be a bit 'thin'. In your opinion is the second version an improvement?

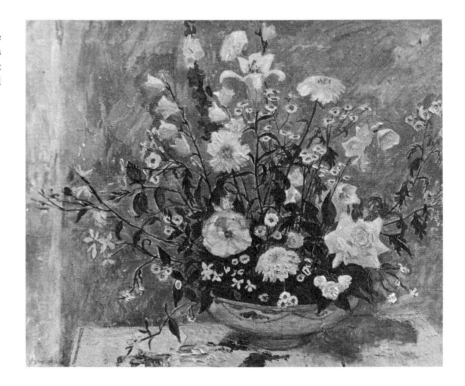

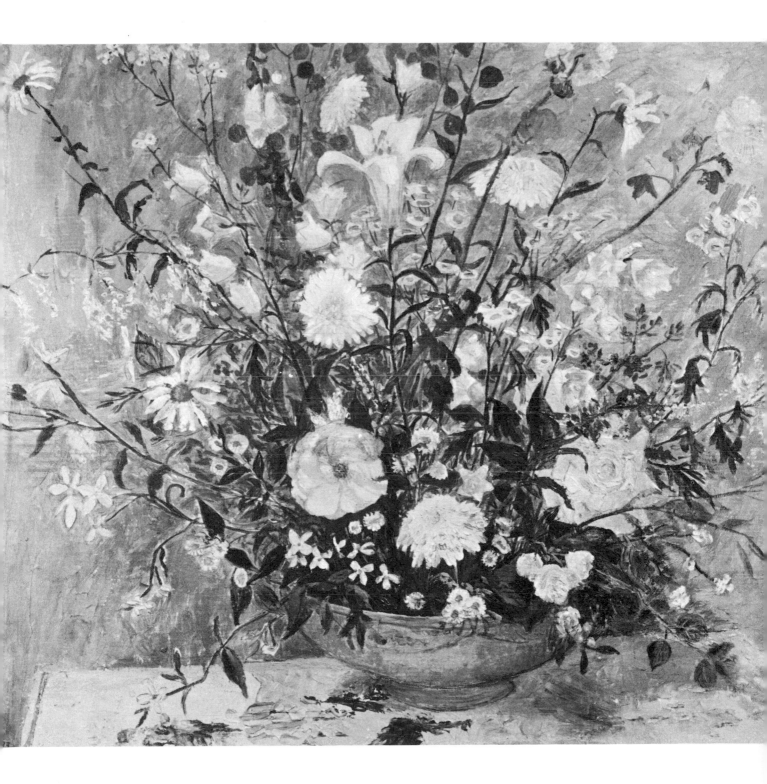

11 The elements of art

A colourful landscape will evoke in the painter a response to colour. A pit head complex might stimulate a response to 'line'. Reflections in a pool may promote a feeling for light. The Rocky Mountains are likely to stimulate a sense of the grandeur of three-dimensional form. Michelangelo transcribed, and his work induces, a response to the majesty of the human form.

It is easily possible to teach basic techniques and to impart information in the form of 'directions for use'. The more subtle processes of the development of sensibility, sensitivity, individual traits, likes and dislikes, which decide how the student deploys his technical skills, cannot be taught. They must be absorbed and developed through experience, by the student, for himself. The best a book can do is to pose problems, advise on how to set up situations which will enable the student to test his own personal sensitivities. He cannot go forward until he knows what these are. What is it for instance about a natural scene, or about a painting of a natural scene, which touches his most susceptible aesthetic chord; the colour? If it *is* colour this could mean that he responds most strongly to colour in *all* pictures. Colour is one, in my view the most important, of the 'elements of art'. There are a number of other elements. All paintings have combinations and permutations of these in their make-up. They are 'line', 'texture', 'shape', 'pattern', 'form', 'decoration', 'rhythm', 'tension', 'composition', 'balance', 'tone', 'design', 'harmony'. Perhaps you know already which of these elements is most highly developed in you. Have you ever thought about it? It is essential to know. You must search continuously. Picasso when questioned said, 'I do not search, I *find*!'

Look at the landscape illustrated opposite. Which of the elements of art can you discern in it? Which one seems the most dominant to *you*?

It is the varied combinations of the elements of art in an artist's work which produces his characteristic style. A combination of line and texture will result in a style which is totally different from a combination of colour and pattern.

Let us think about the elements, taking them in the order listed above. Most of them can be recognized either visually or by touch. The others are more likely to be noticed by their absence than by their presence. For instance some works are unsatisfactory because of lack,

Red Landscape by Norma Jameson. Oil 72 × 48 in. (180 × 120 cm). The structure of landscape transcribed in terms of pattern.

of balance, or lack of harmony. Experience is the teacher which will help you to recognize such deficiencies.

Colour

Colour is universal. It is everywhere in the environment. We constantly have to take it into consideration. We must make decisions and choices about colour schemes for house interiors and exteriors, for dress, for a vast range of manufactured products, for gardens, We cannot escape colour. It is part of every aspect of our lives.

All colours derive from the same basic group of pigments, but before they can be used they must be rendered usable by being mixed with a suitable medium. Take burnt sienna as one basic pigment. It is a natural earth originally found near Sienna in Italy. It is burnt, or fired, and then finely ground with oil. When the process is complete we have a rich red-brown oil paint. When the same burnt earth is ground in water and gum we have watercolour paint. When it is ground in water plus gum plus white we have gouache; and so on with tempera and the rest. The pigment is the same in each case. The medium is different.

If you are interested in experimenting with different painting techniques you may want to try preparing your own paints whether in oils, watercolour, gouache, or tempera. You will need a glass muller and slab plus a supply of pigments in powder form. Mullers and slabs can be obtained from pharmaceutical and laboratory supply firms. (They are manufactured by E. J. Foley, Cranbourne Road, Potters Bar, Herts, England.)

Colours used for painting vary in the way they behave. Some fade, some interact one with another, some stain, some are strong, some are weak. It takes a good while for the painter to become accustomed to the different characteristics of each. So do not be discouraged if sometimes progress seems to be slow. The best, and only, way to learn the personality of different colours is by experience; sometimes painful experience.

When you have experimented enough to give you a confident grasp of the characteristics of different colours select a palette which will make you feel that you can do anything you want, but not so wide as to confuse you. Build up your palette slowly, by first testing each colour and becoming familiar with it.

You may find you will need sets of colours for different types of subject – life, still life, landscape, portrait, abstract.

The painter has to work with various types of colour. For instance 'local colour' is the true colour of the surroundings; grass is green; sand, in normal light, is grey/yellow ochre. But even though we know

Use the muller and slab to gently grind the artist's powder colour in the dry state, then add raw linseed oil. Mix to a paste with a palette knife and grind again with the muller. During the process constantly gather the paint together from the edges of the slab and the sides of the muller with the palette knife so as to keep it all moving together to ensure an even grind.

grass is green in certain lights it can appear to be red, or brown. A white cap of snow on a mountain top can be brilliant pink at sunset when bathed in the red light of the setting sun. If a blue pot is standing next to a white pot a reflected blue will appear in the white, and a reflected white will be visible in the blue. So the artist has to contend with local colour, reflected colour, and the effects of coloured light sources. No colour is ever simple. It is always a complex of local colour affected by reflected colour and also modified by coloured light.

An interesting colour experiment can be carried out by taking a small block of white-painted wood 4 × 1 in. square (10 × 2.5 cm). Stand it, on end, on a sheet of white paper with another sheet pinned up behind it. Take two spotlights, or electric torches. Fix a green transparency in front of one light source and a red transparency in front of the other. Direct both light beams at the block of wood, green from one side, red from the other. What you know to be a white block is now seen as a green and red block. It casts a red shadow on the green side and a green shadow on the red side.

Colour theories are not always helpful in the context of practical painting. Colour is a visual experience, not a set of mathematical calculations and formulae. If the painter has rendered himself sensitive to colour, and has acquired the ability to mix, analyse, and match colour visually, he will be able to cope satisfactorily with colour problems.

In my early days of painting I found difficulty in mixing the colours I wanted until one day somebody said to me, looking at my latest picture. 'Do you *really* see the colours like that? Yours all seem to me to be so much brighter – the real ones seem to contain more grey.' This came as a revelation to me. Yet it was so obvious. From that moment my problem was solved. I developed the habit of mixing a grey first, from a scale of five neutral greys and then adding the appropriate colour. The five greys were: dark grey, medium dark grey, medium grey, medium light grey, and light grey. This is a visual process, not a formula. Using it to analyse say, navy blue, one sees the grey nearest in tone is dark grey; mix that. Then add the nearest blue; Prussian blue? Take another example, sand. How would you mix that? Medium light grey plus a little yellow ochre? A road surface may be a number of medium greys plus varying amounts of dull greens, terre verte, and quiet blues, cobalt. The whole process of matching is achieved by visual assessment.

Colour can be used to produce or heighten the emotional effect. Appropriate colour used with related subject matter has a reinforcing effect upon it, blue for cold sombre themes, red for fire, for passion, green for serenity. Van Gogh's addiction to yellow is well known; it produced within him a kind of ecstasy. The painter should experiment with this theme. An example of this use for colour can be seen in Picasso's 'blue' period. Such use of colour is based upon the evocation, or representation of mood by means of colour. At the time, Picasso was living in Montmartre, the district in Paris which was the haunt of paupers, prostitutes, *clochards*, and of *midinettes* stitching day and

Look at your environment. Sort out the tones of dark and light and match them with the grey scale.

| Dark Grey | Medium Dark Grey | Medium Grey | Medium Light Grey | Light Grey |

night for a few centimes. It was a social set-up of deprived and unfortunate human beings. Picasso movingly portrayed their misery and destitution using a palette of muted and sombre blues. Later there came an altogether happier time in his life coloured by success and love. This was reflected in lyrical paintings executed in high toned colours, predominantly pink.

Many artists believe that a painting can be adequate and complete with only colour as its content. Make a beginning by testing your reactions to colour in the abstract.

Look back to the colour study on page 50 which suggested carrying out exercises by mixing carefully graduated shades of yellow, and covering the whole paint surface with diverse yellows, in differing shapes, with contrasting brush and knife textures. Paint one or two of these. When you have finished them put them in simple frames (see pages 106–7), and hang them where visitors can see them. Note their reactions. Treat the whole range of colours in the same way, all reds, all blues, all greys, all whites. Each picture one family of colours only. By the time you have experimented with all the colours you will have improved your sense of colour considerably. It is a short step from this exercise to arranging all-white still lifes, all-green landscapes, a black and grey industrial landscape, a power station for instance. Pose a red-dressed model in a red armchair on a red carpet before red curtains. These studies will all help your sense of colour.

In the early days Rowland Emett, before he began working on his fantastic and magical machines, spent a good deal of his time painting in oils. His insight into the Cotswold landscape was profound. One day I was in distress with the problem of matching a colour I had used in a Yorkshire landscape. 'What's the trouble?' he asked. 'I can't match this colour,' I replied. He looked at me, then at my painting, smiled and said slowly, 'Why bother?' That was another short sharp comment from a sympathetic observer which changed my way of painting. Why indeed. I never 'bothered' again and the liveliness of my painting improved from that moment. Pay attention to what viewers say. They can help.

On the other hand one must be able to analyse colour in order to construct a colour harmony and one must be able to match colours, for some purposes. The two processes are interdependent, and worth comparing. The practice of colour analysis can be carried on all the time no matter where you are. Think again of the five tone grey scale, light grey, light medium grey, medium grey, medium dark grey, and dark grey. Now let us apply it to the immediate environment. We will take four examples through the window in my study. (1) The road is medium light grey with a touch of dull greenish blue. (2) The walls

of the house opposite are medium grey with a high percentage mix of either raw sienna or yellow ochre. (3) There is no pure spectrum colour to be seen, no red, yellow, orange, green, blue, violet anywhere. All the colours I can see are degraded. The privet hedge is the nearest to a pure colour, green; and even that is a grey green because it is mid-January as I write this. (4) The privet is medium dark grey plus a low percentage mixture of viridian and yellow ochre. And for good measure, inside my study the typewriter case is medium dark grey plus blue violet. This is the analytical process. If you practise it while you are about your day's work, it will greatly sharpen your colour sense.

The practical application of the colour analysing process is colour matching; so set yourself the task of making say six matchings per day. Make a list of six surfaces with degraded colour. Paint six small areas, offcuts of hardboard, say, 4 in. (10 cm) squares. At the end of three months you will be able to analyse and match the colour of anything. When you have enough, mount and arrange the finished squares as a wall decoration.

Corroboration of the contention that the colours in the environment are virtually all grey colours is provided by the fact that when it is necessary, for social reasons, to make sure people can easily see the pillar box, the telephone kiosk, road signs, this is accomplished by painting them in either spectrum colours – red, orange, yellow, green, blue, or violet – or in stark black and white, on the principle of providing visual contrast. Pure colour provides contrast to degraded colour.

Line

Scientifically speaking there is no such thing as a line in nature. What we call a line is in fact a convention, or an invention which artists and laymen from the caveman onwards have used to decorate surfaces and, in later times, to write with. The nearest thing to a line in nature is what you see in the three diagrams on this page. In the first diagram there is a boundary between A and B. It can be represented by X in the middle diagram. But if you examine X under a microscope you will see not a line but an area as in the third diagram, and in that you see three areas with two boundary lines between them. This is not mere quibbling but an attempt to identify two types of so-called line: the line in painting which is conventionally used to map out area boundaries, and line as line used as a convention in its own right, and as decoration, or as drawing. Drawing is the activity with which we mainly associate line. A system of using line in the mapping sense is most truly drawing. Using line to lay areas of crosshatching, so-called shading or stippling, linear texturing of various kinds, and pattern making, is really painting.

The Terrace by David Jones (b. 1895). Watercolour, 25 × 19½ in. (60 × 48 cm). This comparatively large-scale watercolour is carried out in a series of broken washes of fragile delicacy and yet the painting is notable for its tensile strength and its luminous simplicity. It shows a remarkable combination of the two elements of opalescent colour and texture.

The boundary between area A and area B provides an edge. Strictly speaking it is not a line, though it is frequently represented by a line.

126

(*top*) *Above Llandre, Wales* by Kenneth Jameson. Oil on board, 20 × 30 in. (50 × 75 cm). It is interesting to see how many of the elements of art are brought into play in the production of even a simple landscape.

(*below*) Portrait by Sir Godfrey Kneller (1646 or 1649–1723). Pastel has a number of seemingly contradictory qualities: it is one of the most fragile of the media and yet a pastel painting if treated with care is one of the most permanent as to colour.

Churchill Theatre and Library, Bromley, Kent: the podium cladding consisting of random strips of Broughton Moor riven green slate.

Texture

How do you define texture? I mean texture in general not just in terms of painting. *The Concise Oxford Dictionary* gives 'arrangement of threads etc. in textile fabric, as loose texture; arrangement of constituent parts, structure; representation of surface of objects in works of art'.

All textures are surfaces or have to do with surfaces, and conversely all surfaces have texture. There are two kinds of texture, the organized or regular, and the amorphous or irregular. I suggest there are more of the amorphous kind in nature. Imagine massed footprints on the dry sand of the beach. Look down on an area of forest in winter and you will see the amorphous texture produced by a sea of bare branches and twigs. The bark of a plane tree is an amorphous texture. The pebbles on a pebbly beach produce an amorphous surface.

The architect makes great use of natural and artificially made textural effects. A good example is illustrated: the architect used fillets of slate to clad the walls of the new Churchill Theatre in Bromley, Kent. The result is a subtle blue-grey organized texture. You have the choice of *making* the texture you want to use or you can look at nature and extract a natural texture. But you can only begin to select or make or abstract when you have developed your sensitivity to texture.

Read the next few words or phrases to yourself, slowly. What sort of visual image does each one bring into your mind? Gravel, short cut lawn, door mat made from coconut fibre, candlewick bedspread, thatch, brick wall, pond ruffled by a strong breeze, a large area of corrugated

The square grids represent modules in the 'design' sense. The granular and linear modules are modules in the 'texture' sense.

iron, a bowl of uncooked rice, a reed bed. All these have one thing in common. They are all agglomerations of modules or units. The rice is thousands of small ovoid forms, all the same sort of shape, but all very slightly different. In the mass they make a textured surface. The reeds, the corrugations and the thatch are linear. Candlewick is a cotton material with a surface composed of thousands of small nodules, water has wavelets, the brick wall has varicoloured rectangles.

The diagram shows a grid of twelve squares all of equal size. They are twelve modules. The second diagram shows one module detached. The third shows modules within modules. The first square contains linear modules suggested by grass stems, the second contains pebbles or ovoid modules, the third contains irregular stone chippings which vary considerably, but are basically similar in geometric structure. The eleventh is filled with a piece of paper folded into a concertina texture and giving linear modules. In the art sense textures can be made, drawn or painted.

Make a set of 6 × 6 in. (15 × 15 cm) modules using substantial paper. Cover each one with a different kind of scribble. Use soft pencil or fibre-tipped pen, or ball-point pen. Then paste them as a group on a flat card. With eyes shut pass the tips of the fingers over the surface of the paper modules. It is unlikely that you will be able to identify them by touch. All of them will feel smooth, however dramatic they are to the eye.

Make a set of hardboard, or better still thin plywood, modules 6 × 6 in. (15 × 15 cm). Fill each one with a different made texture. Take a metal punch and hammer, and punch holes all over the first module. Take a saw and cut grooves all over the next. Pound another with a hammer. Take a small hammer and a short length of pipe, $\frac{1}{2}$ in. (1.5 cm) diameter, and hammer rings all over the surface. With an electric soldering iron, burn holes. Take a drill and drill through. The nature of these textures will be detectable by touch with eyes shut, or in the dark. Some textures will be visual only, others will be tactile, some will be both.

The various painting media lend themselves in differing ways to textural expression. The watercolour medium will give smooth textures only. Heavy textures must be drawn with the brush. Pastel is a smooth, two-dimensional medium. In this, too, heavy textural effects must be drawn. Gouache can be built up to some degree by using thick paint. Fresco texture is dependent upon the roughness of the wall upon which it is painted. Tempera is best painted smoothly and textures indicated by drawing, though tempera impasto can be used successfully. Encaustic can be built up into heavy three-dimensional textures. Polymers are second only to oils for providing heavily textured paint surfaces and, in

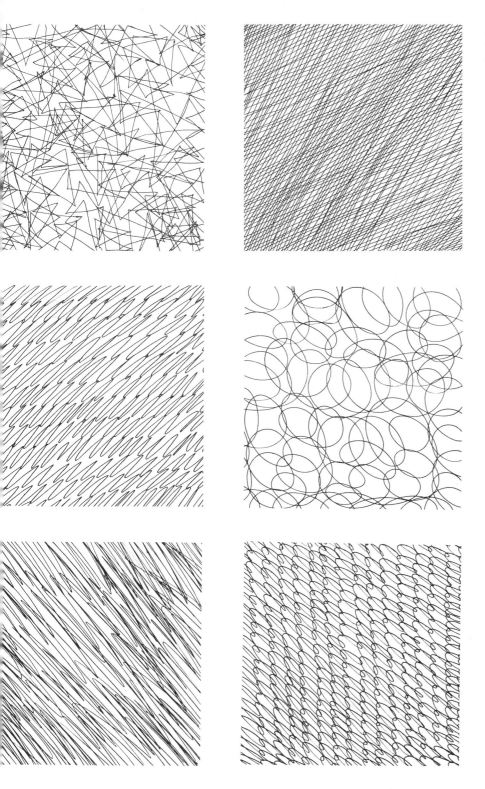

A set of modules containing textures. In this case they are made, on the flat, by variations of scribble.

addition, special pastes are available to increase the rough tactile effect (see page 75). Oils are supreme for creating paint textures. Some of Van Gogh's paintings are textured or impastoed to a depth of 1 to 1½ in. (2.5 to 4 cm). The amount of pigment must have weighed 40 to 50 lb (18 to 23 kg). Some artists, not satisfied with the paint alone, introduce and mix with the paint layer stone chippings, fibres, sand, tea leaves, palette scrapings, and all kinds of other substances in order to enhance the textural effect. Heaven help the picture restorer a hundred years from now!

The crux of the matter is for the student to make himself sensitive to all types of textures whether painting them or merely enjoying them visually. Whether in town or country they are all around. Further simple studies of various kinds will help you to appreciate textures.

1 Make a number of modules, say 6 in. (15 cm) square, of as wide an assortment as you can find of white textiles: towelling, corduroy, seersucker, felt, knitted fabric, nylon, imitation fur fabric, for example. Choose a suitable piece of hardboard. Paint it white, preferably with emulsion paint. When it is dry choose a strong clear adhesive, or a white one such as a PVA variety, and carefully mount your textures on the white board. Mount them close first time. Vary the mounting in subsequent attempts. You will be surprised how attractive the collection will look. Try the experiment, suggested elsewhere, of hanging it in your home, somewhere obvious, where visitors are bound to see it. Note their remarks. This simple study will also surprise you by the degree to which it makes you sensitive to textures in clothes and domestic textiles. It and every other new experience will add to your general appreciation of the important element of texture, and will add to your repertoire as a painter.

2 Try the experiment of changing from the above textile medium to oils. Repeat the study using the same visual images but this time transcribed into oil paint.

3 Another interesting experiment with textures, in oils, is to select a suitable landscape, analyse the main shapes in it, and set those down on a board or canvas. Then paint into the shapes textures which are implicit in the landscape itself; for instance the linear effect of furrowed ploughland, and of stubbles, the nodular effect of full-blown cabbages in a field, the angular forms of jutting rocks. If you base your picture on the shapes and textures, and take *only* those two elements, you will produce an almost abstract work and, who knows, from this starting point you may discover this is the way in which you prefer to work.

Textures play their part in the formation of a painter's characteristic style. Some artists paint with an immaculately smooth paint surface, some paint with deep impasto. Some *represent* heavily textured surfaces

by drawing with the brush on the smooth surface of the paint film. Some achieve an apparently smooth surface while using rough brushwork.

Paint textures can be produced by using a range of different knives and brushes and modes of applying paint. When working in oil I prefer to make a pile of paint on the palette and then use the brush or knife to scoop it up and lay heavy blobs on the board, or canvas. I then spread out the blobs by a circular movement of the brush or knife until the surface is rough but flat. This style of working results in a lively impasto.

When you have tried the above studies, and others you will think of, you will be infinitely more aware of texture. If the creation of textured surfaces gives you aesthetic satisfaction then no doubt you will seek for opportunities to include passages of texture in your paintings.

Shape

What do we mean by 'abstract'? The terms 'texture' and 'abstract' are closely linked. The studies suggested in the paragraphs on texture were virtually invitations to make abstract paintings. Take a look at some abstract painters' work. It is of two kinds:

1 The picture which is composed of shapes, geometrical or amorphous and combined with one or more of the elements; colour, line, texture, pattern, shape, form. Ben Nicholson in his later work is an excellent example.

2 The picture which comprises shapes which are abstracted, or ex-tracted, from the scene in front of the painter, or from his experience of the total environment, with or without the elements of colour, line, texture, pattern, shape, form, but all of which are simplified, partially or almost completely, from what is there. Modigliani's paintings are a perfect example of work almost totally abstracted from the natural form, in many cases the female human figure. Refer back to the 'all yellow' colour study on page 50. That should have produced from you a pure abstract painting. Abstract art is art based on the use of colour, line, texture, pattern, shape, form, with no emphasis on realistic content.

The work of Ben Nicholson is largely abstract. Seek out some of his paintings either in the original or in reproduction. Study them, especially the later geometrical works. Then try out the following study.

Take three plain white postcards. Coat one of them with light medium grey gouache and the other with dark grey gouache. With Ben Nicholson in mind cut from the two painted cards a series of squares and rectangles of various sizes. Next by placing the grey squares in various combinations of positions on the white card, make abstract compositions in the manner of Ben Nicholson. When you succeed in arranging one which pleases you make it permanent by sticking it

The balancing, arranging and organizing of geometrical shapes within a larger shape is an intellectual procedure belonging in part to the realm of mathematics; but you can only decide by 'feeling' whether or not the finished design is satisfactory.

securely. You might then use it as a basis for a larger work in oil, say, 42 × 30 in. (105 × 75 cm). Make sure that the shapes 'go' satisfactorily together and that the result looks balanced and harmonious. Treated seriously this study will produce abstracts of quality, using shape, balance, harmony and, to some degree, pattern. It will test your sensitivities in a number of ways. You will know instinctively whether it looks 'good' when it is finished. This study is also a subtle test of your powers of composition. Which do you consider to be the most satisfactory of the compositions in the three studies illustrated?

The nearer you get to nature the nearer you are to abstract shape and form.

Pattern

Pattern is the result of shapes related one to another. If you read the words 'Friesian cow' they should conjure up a mental picture of a black-and-white cow. The black in opposition to the white is a good instance of simple natural pattern. The markings of a silver-birch tree's bark make a natural pattern. The tabby cat is patterned. Skies are patterned with clouds.

Form

Shape may be two or three dimensional, though when a 'shape' is three dimensional it is more usually referred to as a 'form'. The silver-birch tree trunk has shapes of black on white, or white between black. The trunk itself is a three-dimensional form: a cylinder. A mountain

seen in the distance appears to be a two-dimensional shape. If it is close at hand it appears to be a rounded solid and so has three-dimensional shape or form. A potato has a silhouette which is two dimensional. If it is held in the hand it is felt to have solid form.

Form in relation to the arts has two meanings.

1 In ceramics, modelling, sculpture, architecture, it means three-dimensional shape. The Sydney Opera House, the statue of Winston Churchill in Parliament Square, London, a medieval pottery pitcher all occupy space, that is they all have three-dimensional shape, or form.

2 Form in its other sense relates to painting, poetry, literature, drama, music, dance, and in these contexts form means the mould in which the work of art is cast, or the shape in which it is made.

In painting the mural is a form, in which a large illustration or decoration is painted on a wall. The form of a miniature is a painting, generally a portrait, which is painted on a small support richly framed and small enough to be held in the hand, worn as a jewel round the neck or as a brooch; the support upon which it is painted is frequently ivory. In oil painting, the portrait form may be a head or a half-length or a full-length, all generally life-size.

In poetry the definition given above still holds good. The sonnet is a shape of fourteen lines which scan and rhyme in a specific order. An epic is a long, narrative, heroic poem. In music the sonata, the symphony, the concerto are all governed by a prescribed grouping of phrases and movements. Literature has its forms, the novel, the essay. Drama has the play, the mask, the fête champêtre. Dance likewise has its forms, the ballet, the pas de deux.

Decoration

Decoration is sometimes confused with pattern and both are as often confused with design. The confusion is semantic and the dictionary is of little help. A floral motif on a tea set is often referred to as a pattern or a design. In fact it is a decoration. The Victorians' use of decoration is, today, considered excessive because it was used indiscriminately and very often irrelevantly. A table is not more efficient or more beautiful to look at if every square inch of it is carved or inlaid with roses. Yet an elegant room is enhanced by a discreet display of roses.

Decoration is an addition which is intended to improve what is already there. The tiara is a decoration to a duchess. It is an addition to the total effect of evening dress. Flowers decorate a festive occasion. A cadenza is added by the composer, or indeed the performer, to decorate a piano concerto. A scattering of contrasting flecks of coloured paint will decorate a plain area of colour.

Good decoration helps the object it decorates. It does not militate

Bowl by Bernard Leach (b. 1887). Glazed stoneware, 9 × 4 in. (22 × 10 cm). Appropriate decoration complements the surface to which it is applied. The brush motif on the bowl achieves this with simple elegance.

against it. Look at the bowl by Bernard Leach, the potter; the decoration *fits*.

Decoration is the application of appropriate design motifs to the surface of the work in hand.

Rhythm

Rhythm is one of the elements in art, but it is not always apparent. It is more likely to be felt. El Greco could be said to be an exception. In *The Resurrection* the rhythmical character of the painting is perceivable from the linear contours of the drawing. The same quality is to be seen in much of Indian art. The piece of Jaipur alabaster carving has the element of rhythm to a high degree.

A more familiar vehicle for rhythm is music. Primitive music is almost entirely based on rhythm. Dance music must be strongly rhythmic in order to fulfil its purpose. Classical music is to a large degree bound together by rhythm.

Read a few lines of Longfellow's *Hiawatha* or listen to a Dylan Thomas recording, prose or poetry, to remind you of the rhythm of words.

The Greek key pattern with its regularly repeating motif is a good example of a visual or graphic rhythm. What is rhythm but a steady beat.

Every well-composed painting has a rhythmical element, an internal correlation of components, but in common with form, tension, composition, balance, tone, design, harmony, it is usually more conspicuous by its absence than by its presence.

136

The Resurrection by El Greco (1541–1614). Oil, 108 × 50 in. (270 × 125 cm).

(*left*) *Figure of Lakshmi, Hindu Goddess of Fortune*, Jaipur, India (nineteenth century). Alabaster carving, height 12 in. (30 cm).

Tension

Tension in painting is the product of a sure eye, a steady hand, a brush loaded with fluid paint or ink, or other marking implement, and exact control over all of these. Tension is evident when the line moves from one point to the next unhesitatingly, with a steely strength and absolute certainty, like a flash of forked lightning. The watercolour painter, in particular, must understand the element of tension. It is not possible to paint a winter tree, to take a familiar example, in watercolour without sensing the tension in the directions and structure of the branches and the trunk. There are many more straight lines than curves in the structure of the twigs, minor branches, major branches and trunk; in fact the curves are mostly made up from short straight lines.

137

If the painter considers tension to be a valuable element for his particular form of expression then he will find the *premier coup* method of painting is the best way to achieve it, and this applies not only to line but to every mark which is put upon the paper. Oriental brush drawings represent supreme examples of tension in art.

Nothing is so unpleasing to look at as flabby drawings and painting.

Composition

The term composition in any of the arts means the putting together of a number of parts to compose a whole. This holds good whether it be poetry, prose, music, drama, film, television, fine art. In writing it means the composing or arranging of the word, the phrase, the sentence, the paragraph, the chapter. In poetry it means composing the word, and the line, and the gathering together of the lines into different shaped groupings; verses; to form a ballad, a sonnet, an epic. In music it means arranging notes, phrases, movements. In drama it means organizing scenes, acts, entrances, exits.

In fine art it means dividing up the picture rectangle into subsidiary shapes so that they fit harmoniously together, so that they look balanced and stable. The shapes may contain colour, texture, pattern; they may be described by line or decorated with line. In composing you divide up the picture plane by referring to the lines and shapes available in the subject and using them. Suppose your subject is a landscape in open flat land, the Fens in Britain or the Prairies in America, the skyline will be a, if not *the*, dominant composing line. You will have various options as to where you place the skyline depending upon how you

Bamboo Shoots by Wu Chen (1280–1354). Ink on silk, 8¾ × 8½ in. (22.8 × 22.5 cm).

(*right*) The line drawing shows the basic structure underlying the scene in the photograph. The painter must be aware of the underlying structure even if he does not use it in the form of a preliminary drawing.

The skyline in a landscape may be placed low or high on the picture plane. Modigliani used his portrait and figure models to achieve harmonious compositions of shapes within the picture rectangle. A still life offers the same opportunities for manipulation of compositional shapes.

decide to treat the landscape and what proportion of land to sky you require. The shapes in and around the human figure used with the rectangle of the picture and the shapes afforded by a still life are the structure which the artist borrows for his compositions.

One of the difficulties experienced by some painters in the early stages of development is the question of how to simplify the complexity of nature. What are the *basic* generalized shapes in the tangled confusion in the photograph on page 139? I have simplified them in the drawing. Compare my sketch with the original, do you agree with my simplifications? Once you have simplified the shapes you can arrange them and also, if you think it necessary, modify them so that they fit harmoniously together and so that they balance.

A device that will help your composition and will help you to simplify and sort out subjects, is the view finder. Make one. Set up a still-life subject. Study the subject and make sketches of it through the view finder, held at arm's length, from various angles. The composition will vary each time. Which of the compositions do you prefer?

Composition is a process of dividing up the painting area; or building into the painting area a series of shapes, large or small, suggested by the shapes in the subject, so that they fit completely and harmoniously into the picture shape and with each other. When this layout is established, the larger shapes can then be subdivided into smaller areas and as many of them as is appropriate modified by the addition of colour, texture, line and pattern. Which permutations of these he uses will depend upon what the painter uses from within the subject before him or the concepts he draws from within himself.

Balance

Balance in the visual sense is difficult to define verbally, so in this attempt to convey something of the meaning of the term, use is made of a few graphic symbols. Look at the symbols on page 142. Which ones seem to you to be best balanced aesthetically?

Psychologically, dark colour *appears* to be heavier than light colour. In the same way powerful colour seems heavier than gentle colour. This means that thought must be given to the distribution of the weight of colour and tone about the canvas. The concentration of too much heavy colour on one side will make for imbalance. If one side of the picture is painted in great detail and the rest of the painting surface is carried out in a nebulous style, the detailed section will attract more attention than the rest of the painting. If the painter does this involuntarily then it implies a faulty sense of balance. If on the other hand it is premeditated then it is likely that the artist considers that a sense of imbalance is appropriate to his subject matter.

140

Use the viewfinder as you would use the camera viewfinder to separate the subject from the distraction of its surroundings. Let it help you to decide proportion and scale. The photograph (*top*) shows the original still life. The three sketches were made through the viewfinder from three different viewpoints.

Tone

The term 'tone' in its painting context (it has a musical context too which is different from the painting definition) means the quality of lightness and darkness. You can paint a light or a dark picture. The difference is one of tone. You can paint one which is highly contrasted from light to dark, from white to black, within itself. The resulting dramatic effect is a tonal quality. If you produce a painting which is mostly white and very pale colours, it would be said to be painted to a narrow tone scale. If some areas were very light and the others very dark, it would be said to be painted to a wide tone scale. If you used all very light colours it would be said to be painted in a high key. All dark colours would be designated as a low key. Note the use of 'key', a musical term.

Tone is the handmaiden of form. Without tonal differentiation form disappears, or appears to do so. Try an experiment. Paint a small oil in which you vary the colour but keep the tone uniform. Shut one eye and narrow the other one to a slit (do this in a poor light). Look at the painting you have just made. The content of the picture will virtually disappear. Take a photograph of it in black and white. The colours will fuse and the painting will *appear* to be blank. The above 'shut-eye' test can be used while painting to judge comparative tones.

Design

The term design has many meanings and even within the special context of the fine and applied arts it has several distinct connotations. 'A design' means a motif which is used as decoration. 'Design' on the other hand is a branch of activity within the field of fine and applied art. It refers to such media as: fabric design (batik, embroidery, screen printing, block printing); graphic design (photography, film making, lettering, typography, lithography, printing, etching and other print techniques); interior design (the creating of domestic and public interior environments); industrial design (making sure that the aesthetic component in consumer goods is taken into account at all stages of production); book design (layout, illustration, typography); architectural and environmental design (planning of buildings, groups of buildings, and communities and their urban or rural settings).

It is the job of the designer to produce order and harmony from a multiplicity of considerations. To do this he must solve problems of reconciling aesthetic considerations with his client's demands for functional efficiency. This puts constraints upon the designers' creativity; some constraints are not a bad thing. Beethoven accepted the constraints of the symphonic form and rose so much above them that he produced some of the most significant works of creative art the world

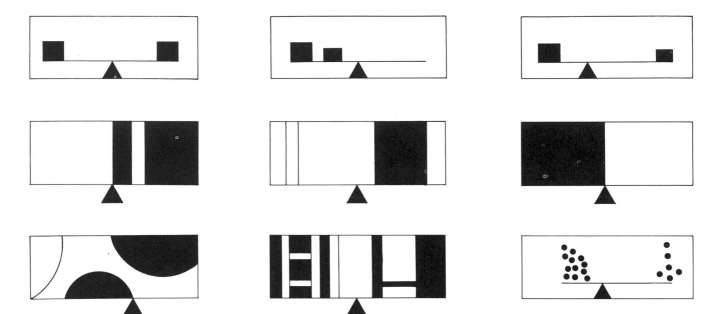

has ever seen. The good designer, or design team, in consultation with the radio engineer, takes hundreds of parts and assembles them within an enclosure so that the radio will function efficiently and be gracious in appearance. This calls for 'good' colour and a balanced and harmonious arrangement of control knobs, tuning scales, loud-speaker grills and so on.

Design procedures must also apply to the production of a painting. The painter must organize shapes, pattern, paint, texture, scale, line. All these have to be taken into account in order to produce a satisfactory whole. Normally we use the term composition for this process. There is, however, one important difference between designing a refrigerator and composing a picture and that is the artist, generally, is not put under constraint. He is free to create as he wishes. Exceptions to this occur in the case of portrait painting and in some commissioned work, but in general the artist is a free agent.

Examples of balance and imbalance: one group is evenly balanced; the second is unevenly balanced; and the third is unbalanced.

Harmony

The term 'harmony' has virtually the same meaning in both painting and music. A harmonious composition is one in which the colours and other components sit together in a pleasing manner with no one colour, or component, obtruding more than any other. A harmonious composition in music is one in which the chords and key progressions are consonant and pleasing to the ear, and the pitch and intonation are exact.

If a painting is carried out in varying shades of green all over and

one bright scarlet patch is placed in it, the red, because it is the complementary colour of green, the strongest possible contrast to it, will stand out powerfully against it. It will *fight* with the green. It will not harmonize with the background.

The 'blue-period' paintings of Picasso are harmonious.

A painter makes use of harmony and disharmony for creating calm or dramatic effects. Play a chord of C major in the middle of the piano keyboard and you will produce a calm, pleasant, harmonious sound. Play a chord consisting of C, D and E flat at the top end of the keyboard and you will make a strident sound which sets your teeth on edge. The first chord is harmonious, the second is a sharp dissonance.

Without balance, rhythm, tone, harmony, no work of art can be wholly satisfactory.

An analysis

Perhaps we should now attempt to summarize the recent paragraphs which have dealt individually with the various elements of art. A tidy way to do so would be to analyse a typical landscape and see how many of the elements are contained in it. Painted in Wales some time ago, the landscape is reproduced in colour on page 128 and in black and white on page 144, together with an analysis of it. The diagram simplifies the main lines of the composition and acts as a reference grid.

The composition was carefully worked out beforehand and a simple working drawing was set down. The plywood panel was then taken to the site and the painting was completed rapidly, in one day. My method of work, when painting landscape, is to live in an area long enough to become intimate with its character and conformation, and to wait for subjects to impress themselves upon my inner mind. I then feel able to work rapidly and confidently.

Having worked through the analysis, it is interesting to see that so many of the elements are brought into play in the production of even a simple landscape sketch. The only element that was not employed in this work was decoration.

The aim of this book is to provide information, to encourage experimentation, and to lead the reader to a point from which he can step out into his own world of discovery. It aims to prompt him to explore new avenues of approach, new media, and new ways of using raw materials.

It may take weeks, it may take years for you to see which way you should go, but, if you will examine your own inner feelings, your own unique and personal way ahead will, sooner or later, reveal itself to you.

Welsh landscape for analysis.

On the day this landscape was painted the light was strong and from the left. It produced enough dark tone, on the shadow side, adequately to define all the forms and these help to provide a structure for the work.

The outlines in the diagram show the linear structure upon which the composition rests, and the intersections of the lines produce a series of subtle but powerful shapes. The sky shape, X, right across squares A1, A2, A3, A4 is a good example, as are also the grass shape, Y, in square C1, and the pathway, Z, in squares C1 and C2. The diagram makes it possible to see the way in which the lines of the beech tree's branches sweep in a wide curve across squares B2 and B3, and are rhythmically echoed by each other and by curves in the earth forms throughout the painting.

There is a strong linear emphasis provided by the trunks and branches.

I took care to retain as far as possible the tension in the directions of the branches of the main tree and of the boundaries of the land forms.

The colour (see page 128) is set in a high key of browns, ochres, and greens suggested by the Welsh atmosphere. I hope you feel they work harmoniously together. The tall brown hedge to the right of the main tree, B4, is represented by a patch of linear brown texture. The foreground, C1, C2, C3, C4, is textured with bracken and broken green grass tussocks.

A feature in the subject which strongly attracted my eye was the patterning on the large beech trunk, B3, B4, C3, C4.

Form is present in the recession of the landscape and noticeably in the solidity of the beech tree trunk.

Balance in the painting is vitally controlled by the placing of the two main tree forms. At the time of painting it posed a subtle problem. I hope the viewer will find my solution satisfactory. It is not the only solution.

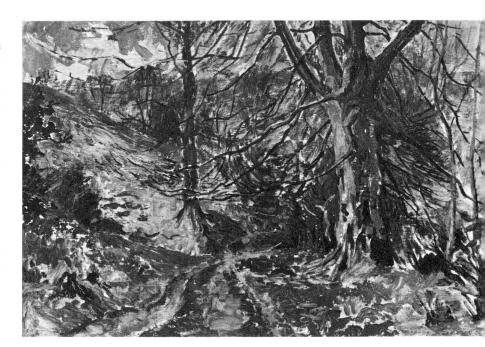

144

General suppliers

The following list of suppliers offer mail order facilities.

Australia

OSWALD-SEALY (OVERSEAS LTD), Box 268, P.O. Artarmon, New South Wales 2064

REEVES (AUSTRALIA) PTY LTD, 25 Clarice Road, Box Hill South, Victoria 3128; and 422 Frederick Street, Royal Park, South Australia 5014

WINSOR AND NEWTON PTY LTD, 102–104 Reserve Road, Artarmon, New South Wales 2064

Canada

THE HUGHES CO. (LTD), 8500 Decarie Boulevard, Montreal, Quebec

METRIC AIDS LTD, 75 Horner Avenue, Toronto 18, Ontario

REEVES (CANADA) LTD, Downsview, Ontario

GEORGE ROWNEY (CANADA) LTD, 2180 Highway No 7, Concord, Ontario

England

CLIFFORD MILBURN LTD, 54 Fleet Street, London EC4Y 1LT

REEVES AND SON LTD, Lincoln Road, Enfield, Middlesex EM1 1SX

ROBERSON AND CO. LTD, 71 Parkway, London NW1 7QT

GEORGE ROWNEY AND CO. LTD, P.O. Box 10, Bracknell, Berkshire RG12 4ST

WINSOR AND NEWTON LTD, Wealdstone, Harrow, Middlesex HA3 5RH

Europe

REEVES (EUROPE) LTD, 7 Place Georges Brugman, 1060 Brussels

Mexico

STAFFORD REEVES DE MEXICO, Colonia, Mexico 15 DF

New Zealand

A.R.B. STOKES, Druids' Chambers, Woodward Street, Wellington

WILLIAMSON JEFFREY LTD, P.O. Box 386, Anzac Avenue, Dunedin

South Africa

REEVES (SOUTH AFRICA) PTY LTD, 10–14 Newlands, Johannesburg

U.S.A.

ARTHUR BROWN AND BROS INC., 2 West 46th Street, New York, NY 10036

M. GRUMBACHER INC., 460 West 34th Street, New York, NY 10001

LEISURE CRAFT, 3061 East Maria Street, Compton, California 90221

THE MORILLA COMPANY INC., 43–01 21st Street, Long Island City, NY 11101; and 4552 Colorado Boulevard, Los Angeles, California 90039

UTRECHT LINENS INC., 33 35th Street, Brooklyn, New York, NY 11232

WINSOR AND NEWTON INC., 555 Winsor Drive, Secaucus, New Jersey 07094

Illustration Acknowledgments

Photographs and illustrations were supplied or are reproduced by kind permission of the following. Laing Art Gallery and Museum, Newcastle upon Tyne, page 22; The Walker Art Gallery, Liverpool, page 25; City Art Gallery, Temple Newsam, Leeds (Photo: Gilchrist), page 52; Courtauld Institute Galleries, pages 57, 117; Norma Jameson, pages 68, 88, 101, 121; Ben Nicholson (Photo: Courtauld Institute), page 110; Mr and Mrs Frederick Weisman, Los Angeles, page 94; The Museum of Modern Art, New York, pages 96–7; National Gallery, London, page 103; Palacio Nacional, Mexico City, page 104; The Tate Gallery, London, pages 108, 127; Giraudon, Paris, page 109; Musée d'Art Moderne, Paris (Photo: Musées Nationaux), page 114; Douglas Seymour, page 115; The Earl of Lisburne (Photo: Derrick Witty), page 128; Horniman Museum, London, page 137 (left); Museo del Prado, Madrid (Photo: MAS), page 137 (right). The picture on page 34 is reproduced by courtesy of the Victoria and Albert Museum, London; on pages 102, 138 by courtesy of the Trustees of the British Museum, London; on page 109 by courtesy of Mr Harry Holtzman (Photo: The Tate Gallery); on page 129 by courtesy of Aneurin John, architect of the London Borough of Bromley (Photo: courtesy of Laticrete Limited).

The illustration on page 51 was photographed by Christopher Ridley; on pages 26 and 128 by Derrick Witty; on page 127 by John Webb. Special acknowledgment is due to John Hunnex who took most of the working photographs: pages 15, 17, 23, 31, 33, 37, 38, 42, 47, 48–9, 54, 58, 59, 61, 65, 68, 73, 84, 85, 86, 87, 88, 89, 106, 107, 119, 121, 123, 136, 144.

Further reading

Historical and Reference

Bazin, Germain *A Concise History of Art* London: Thames and Hudson 1962

Lake, Carlton and Maillard, Robert (editors) *A Dictionary of Modern Painting* London: Methuen 1964; New York: Tudor 1964

Read, Herbert *A Concise History of Modern Painting* London: Thames and Hudson 1968; New York: Praeger 1969

Read, Herbert (editor) *The Meaning of Art* London: Faber and Faber 1969; New York: Pitman 1969

Weston, Neville *Kaleidoscope of Modern Art* London: Harrap 1968

The Media

Armfield, Maxwell *A Manual of Tempera Painting* London: Allen & Unwin 1930

Dehn, Adolph *Water Color, Gouache and Casein Painting* New York: (Studio) Crowell 1955

Gettings, Fred *A Polymer Painting Manual* London: Studio Vista 1971

Gutierrez, Jose and Roukes, Nicholas *Painting with Acrylics* New York: Watson-Guptill 1965

Hayes, Colin *The Technique of Water-colour Painting* London: Batsford 1967; New York: Van Nostrand Reinhold 1967

Hayes, Colin *The Technique of Oil Painting* London: Batsford 1965; New York: Van Nostrand Reinhold 1966

Mills, John Fitzmaurice *Acrylics* London: Pitman 1967; New York: Pitman 1967

Nordmark, Olle *Fresco Painting* New York: American Artists Group 1947

Pratt, Frances and Fizell, Becca *Encaustic Materials and Methods* New York: Crown 1949

Richmond, Leonard *The Technique of Oil Painting* London: Pitman 1969; *Fundamentals of Oil Painting* New York: Watson-Guptill 1970

Savage, Ernest *Pastels for Beginners* London: Studio Vista 1966; New York: Watson-Guptill 1966

Sears, Elinor L. *Pastel Painting Step-By-Step* New York: Watson-Guptill 1968

Sepeshy, Zoltan *Tempera Painting* New York: (Studio) Crowell 1946

Framing

Nuttall, Prudence *Picture Framing for Beginners* London: Studio Vista 1968; New York: Watson-Guptill 1968

Rogers, Hal and Reinhardt, Ed *How to Make Your Own Picture Frames* New York: Watson-Guptill 1964

Handbooks, Painting and Drawing

Dunstan, Bernard *Starting to Paint Portraits* London: Studio Vista 1966; New York: Watson-Guptill 1966

Dunstan, Bernard *Starting to Paint Still Life* London: Studio Vista 1969; New York: Watson-Guptill 1969

Hiler, Hilaire *Notes on the Technique of Painting* London: Faber and Faber 1969; New York: Watson-Guptill 1969

Jameson, Kenneth *Flower Painting for Beginners* London: Studio Vista 1968; New York: Watson-Guptill 1968

Jameson, Kenneth *Starting with Abstract Painting* London: Studio Vista 1970; New York: Watson-Guptill 1970

Jameson, Kenneth *You Can Draw* London: Studio Vista 1967; New York: Watson-Guptill 1967

Kay, Reed *The Painter's Guide to Studio Methods and Materials* London: Studio Vista 1973; Garden City: Doubleday 1972

Laning, Edward *The Act of Drawing* Newton Abbot: David and Charles 1971; New York: McGraw-Hill 1971

Mayer, Ralph *The Artist's Handbook of Materials and Techniques* London: Faber and Faber 1973; New York: Viking Press 1970

O'Connor, John *Landscape Painting* London: Studio Vista 1967; New York: Watson-Guptill 1967

Oliver, Charles *Anatomy and Perspective: Fundamentals of Figure Drawing* London: Studio Vista 1972; New York: Viking Press 1972

Walmsley, Leo *Approaches to Drawing* London: Evans Bros 1972; New York: Van Nostrand Reinhold 1972

Essays and Studies

Churchill, Winston S. *Painting as a Pastime* London: Penguin 1964

Clark, Sir Kenneth M. *Landscape into Art* London: John Murray 1949; Boston: Beacon Press 1961

Leslie, C. R. *Memoirs of the Life of John Constable* London: Phaidon Press 1971; Los Angeles: Hennessey 1971

Sausmarez, Maurice de *Basic Design: The Dynamics of Visual Form* London: Studio Vista 1964; New York: Van Nostrand Reinhold 1964

Periodicals

American Artist published monthly (except July) by Billboard Publications Inc., 1 Astor Plaza, New York, NY 10036

Apollo published monthly by Apollo Magazine Ltd, 10 Cannon Street, London EC4P 4BY

Art and Craft in Education published monthly by Evans Bros Ltd, Montague House, Russell Square, London WC1B 5BX

Art Direction published monthly at 19 West 44th Street, New York, NY 10036

Artist published monthly by Artist Publishing Company Ltd, 33 Warwick Square, London SW1V 2AH

Art News published monthly by Newsweek Inc., 444 Madison Avenue, New York, NY 10022

Arts Magazine published eight times a year by Alvin Kemick, 23 East 26th Street, New York, NY 10010

Arts Review published fortnightly by Gainsborough Periodicals Ltd, 8 Wyndham Place, London W1H 2AY

Athene published twice annually by The Society for Education through Art, Jasc House, 30 Wayside, East Sheen, London SW14 7LN

Leisure Painter and Craftsman published monthly by Creative Leisure Ltd, 249 Lincoln Road, Enfield, Middlesex

Studio International published monthly at 14 West Central Street, London WC1A 1JH

Index